PHOTOGRAPHER'S GUIDE TO

Wedding Album

DESIGN AND SALES

Bob Coates

AMHERST MEDIA, INC. ■ BUFFALO, NY

Dedication

This book is dedicated to my wife, partner, and best friend—all of whom are the same person. I don't say I love you near enough.

Acknowledgments

I want to thank all the photographers who were so willing to share their time, knowledge, images, and ideas. Without them there would be no book. Thanks to Russell Beach for helping to keep my feet firmly on the ground; to Pat Bushey for her technical editing, and to my wife, Holly, who transcribed all the interviews . . . and more.

Front cover photo: Joe Buissink © 2003
Back cover photos: Top—Bob Coates © 2003; Center—Michael Ayers © 2003, Bottom—Jeff Hawkins © 2003

Published by:
Amherst Media, Inc.
P.O. Box 586
Buffalo, N.Y. 14226
Fax: 716-874-4508
www.AmherstMedia.com

Publisher: Craig Alesse
Senior Editor/Production Manager: Michelle Perkins
Assistant Editor: Barbara A. Lynch-Johnt

ISBN: 1-58428-098-0
Library of Congress Card Catalog Number: 2002113007

Printed in Korea.
10 9 8 7 6 5 4 3 2 1

Table of Contents

Introduction

Wedding albums are an immense source of pride and income for the professional wedding photographer. Albums come in all shapes, sizes, and flavors, from traditional, to artful, to digital books that come off a CMYK press.

This book provides a sneak peek into the design and marketing skills of the top wedding professionals in the industry. If you are a wedding photographer and not using your creativity to produce a solid, top-of-the-line wedding album, you are leaving a substantial source of additional income on the table.

When I started photographing as a professional, I never intended to photograph weddings. Living on St. Thomas at the time, a friend convinced me to follow her for one day while she photographed the weddings of island visitors. They were staying in hotels or arriving on cruise ships to get married in the sunny Caribbean. I hated to admit it, but we had fun! At the end of the day (five one-hour weddings later), she

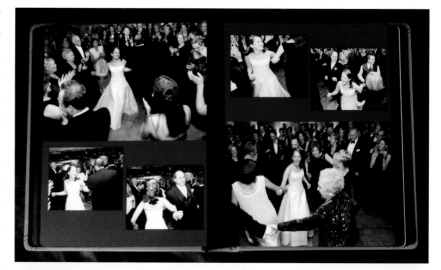

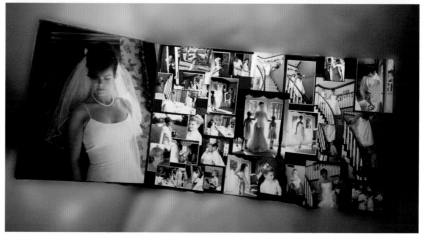

Wedding albums are an immense source of pride and income for the professional wedding photographer. Top album and photos by Charles and Jennifer Maring. Bottom album and photos by Kathleen and Jeff Hawkins.

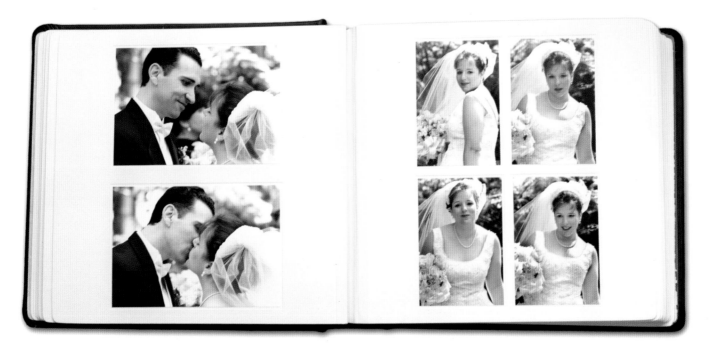

said, "How can you not want to do this? You get to spend the happiest time of these peoples' lives with them. Last year I made $40,000 doing this."

The following week I was shooting weddings—and not just for the money, although that didn't hurt. I really enjoyed spending time creating beautiful memories for the couples. I just wanted to make images. I didn't have to, or want to, produce wedding albums. Why? Because I didn't want to deal with the mundane mechanics of stocking album pages, carding negatives, spraying prints, and building albums. No drudgery for me! Well, my outlook changed when I realized I could double or triple my income from these weddings by supplying a simple proof album with a very small increase in time invested.

Today, the "drudgery" of creating wedding albums has been greatly reduced with advances in technology. Some album manufacturers mount, spray and texture, bind, and deliver a complete album, leaving you to only determine the layout. With the advent of long roll scanners and digital capture, designing an album can be as easy as playing a computer game. You can completely design, produce, and deliver a stunning, elegantly beautiful wedding album to your bride—without ever touching a negative card, album insert, or print.

When I finally decided that producing wedding albums was an art form that helps preserve the couple's wonderful wedding memories, I started searching for information on how to proceed. I found none on the bookshelf, but got some tips from other photographers. I gathered more information at trade shows, but it was rife with sales hype. While I eventually found the products and systems that now work for me, it took years.

This book contains information from top professional photographers

Album design is an art form that helps preserve the couple's wonderful wedding memories. Album and photos by Joe Buissink.

who have been in the business for many years and have found solutions that work for them. Through these interviews, I found that album design actually begins with marketing and is shaped by such things as the interview with the bride and groom, proof presentation method, the album company, and more. In fact, as you read this book, you'll see that every part of your business helps to shape your album design.

This book is more than a "place this picture here" guide. Check out these photographers' ideas. Take some inspiration from this photographer, a slice of guidance from that one, and twist an idea from another. When you have harvested all you can and melded the ideas together you will have a product that is unique to your business.

1. Ken Sklute

CONTEMPORARY IMAGES LTD., TEMPE, AZ
WWW.CONTEMPORARYIMAGESLTD.COM

Ken Sklute began his photography career at the race track—at the age of fourteen. Initially taking photos to prove to his friends that he actually was at the track, he showed the images to drivers and began selling prints. "I fell in love with drag racing," says Ken. "I panned with an Instamatic and I didn't even know what I was doing, but the results were what they had to be." Before long, he was the official track photographer, but at the age of sixteen he made the seemingly bizarre transition from racing to weddings. "Actually, it was a natural progression," Sklute says with a laugh. "During the winter (off-season for drag racing) I met a wedding photographer and asked if I could come with him. He said yes. I went to weddings with him for three months and booked a wedding for myself so I had a deadline to learn everything by."

Sklute shot more weddings on his own until he caught the attention of a catering establishment with a large studio, which handled as many as eleven weddings at a time. Ken was guaranteed two weddings per weekend, all year long. The transition to wedding photography turned out not to be much of a stretch: one of Ken's first award-winning prints was of a bride and groom on a motorcycle using that panning technique he first used at the track. "I was panning at $1/15$-second," he recalls. "The bride's garter was showing, her veil was blowing, and the church was in the background. That shot came right out of motor sports photography."

Listing all of Ken's awards individually would leave no room for learning how he produces his stunning wedding albums. Now in his forties, Ken has garnered Wedding Photographer of the Year twenty-four times and Wedding Album of the Year ten times from Long Island PPA and the Phoenix Professional Photographers Association. He has also been awarded eleven Kodak Gallery Awards and twelve Fuji Masterpiece Awards. In 2001 Ken won the prestigious Kodak Gallery Elite Award first place. It was the first time it was ever given for a wedding album. Ken also provided the images for the newly-revised *Professional Techniques for the Wedding Photographer* by George Schaub (published by Am-Photo), originally published in 1986. Sklute is also a speaker who is very much in demand.

Ken starts selling his wedding albums as soon as he meets the couple. In the initial interview, he shows samples of the types of books he wants to sell. That's when the seeds are planted to sell a 120- to 150-image book. "I do a planning session that coincides with an engagement session. Sitting with people during an engagement session, I familiarize myself with their taste and start setting up a game plan of how I'm going to work. I look to do photographs

"To sell big

you have to show big . . .

my various sample albums

tend to be

big fatties with 120

to 150 prints."

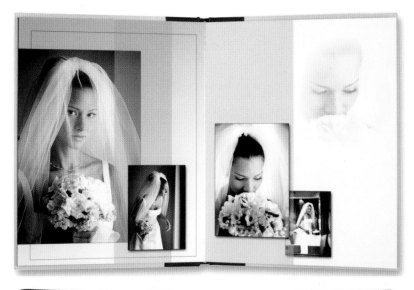

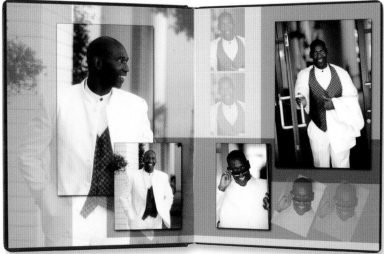

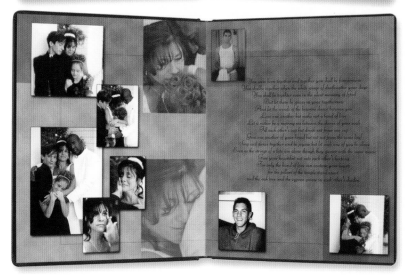

Albums Australia and John Garner Bookcraft produce a magazine-style album. Pages can be designed by the photographer in Photoshop and sent for printing and binding. For those not proficient in Photoshop, images can be sent for the company to design the album.

with people before a wedding so they are comfortable with me and I know what their challenges may be. It gives me a point of reference when we design a timeline for the wedding day. We talk about the importance of being on time. If the bride is a half hour or an hour late the day of the wedding, there won't be enough time to capture a lot of the images you need." Ken also believes that any people photography you do will be better the second time around, and feels that an engagement session breaks the tension of a couple standing in front of the camera for the first time. According to Ken, when the couple sees the results of a photo shoot before the wedding, they are more apt to cooperate on the day of the wedding. This leads to better images, which leads to better sales.

According to Ken, "Samples are the most important tool. People have a hard time visualizing the final product; by showing different styles of books, you find out what their taste is. This is where you reinforce your sale in the number of photographs that you show. To sell big you have to show big," he says with a grin. "Photography studios have always shown big prints—30x40 inches—in order to sell them. It works the same way with an album. If you show a thirty-image album, that's what you'll sell. So the various sample albums I have tend to be big fatties with 120 to 150 photos."

Ken's pricing is based on hours of coverage and quantity of photo-

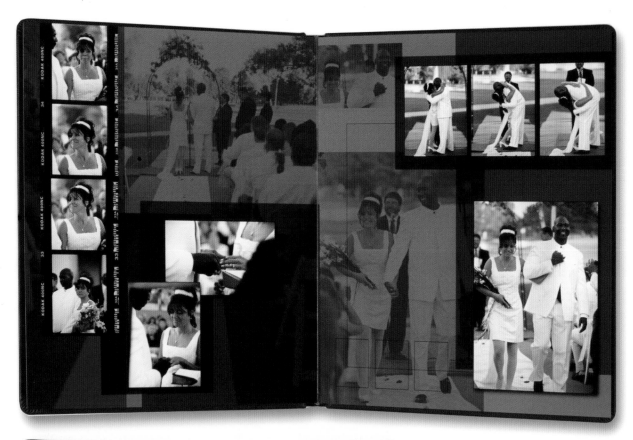

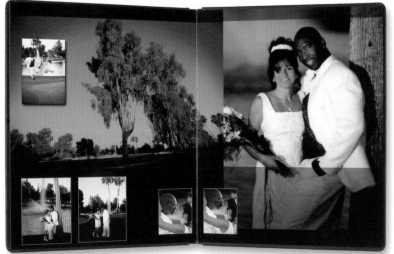

Above, Left and Facing Page—Photoshop allows you to be extremely creative with page layout and design. Note the way some images are ghosted in the background. Multiple images and sequences of similar situations really show the emotional expressions of the day.

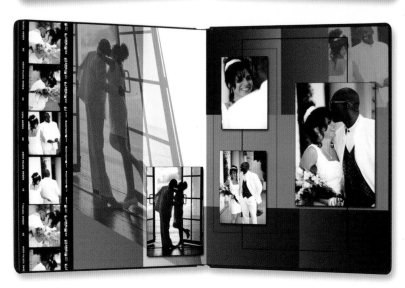

graphs. He books an initial amount of time and number of pictures for the album. "When I explain this to the couple, I let them know that both items can be amended. Many people are used to picking a package and staying with it. You may increase shooting time because you can't really see how much time is needed. But more than that, you can't really see how many photographs it's going to take to complete the narrative of the wedding. With the couple prepurchasing fifty or seventy pictures, they might end up with ninety-four or a hundred plus images that really tell the story. I look at my sales as two-fold. Initially, I book the job where people feel comfortable with what they are getting for a set amount of money. I think of this as a minimum." Ultimately,

the number of photographs in a book is often determined by the kind of day, cooperation, time available, and type of party. All become factors in creating the final product.

"I help design the album—and this could be considered an upsell—but I'm really helping people get the best possible album," says Ken. "Most couples have no idea what their final book can look like. That comes back to us being artists, and at the same time wearing another hat—that of salesman. When clients come in with a structured number of photographs, they very often leave out some important storytelling pictures or really nice pictorials or panoramas because they are too small in the proofs for them to visu-

alize. It takes a little education of the client to design a great album. This ultimately increases the sale."

Asked what album companies he buys from, Ken replied, "I'm using a wide variety of companies right now. I've been with Leather Craftsmen for twenty years; I also work with the Australian companies John Garner Bookcrafts and Albums Australia, as well as Sandis, and Daisy Arts. I find magazine-style albums are very popular right now, digitally produced with multiple images on a single print. There might be two, three, or fifteen images on a page."

How does Ken accomplish his proofing? "I'm now using

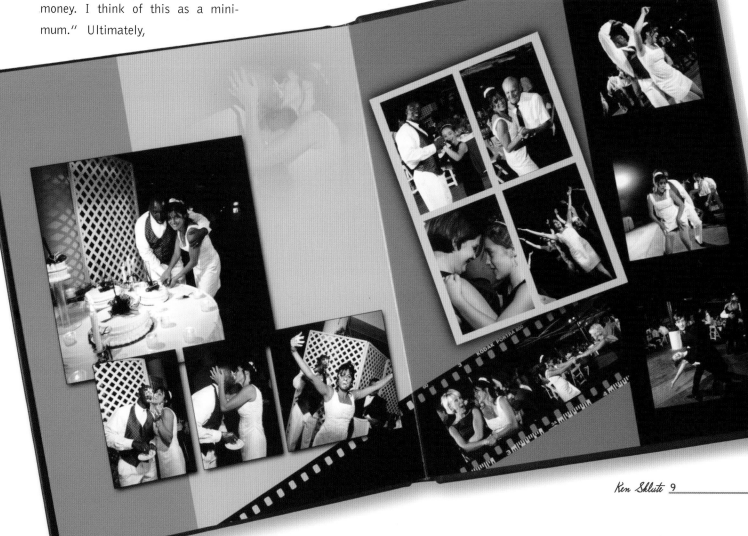

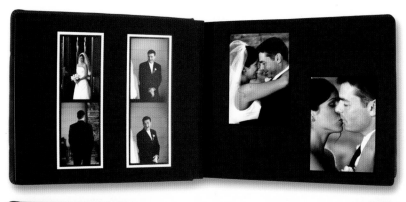

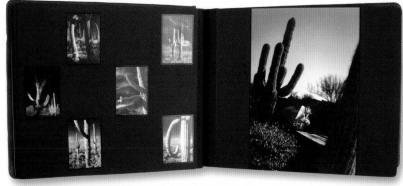

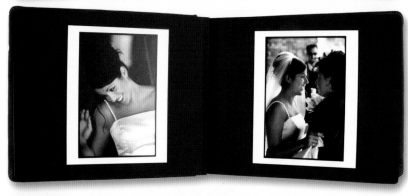

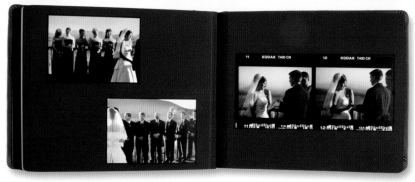

This more traditional album is a Leather Craftsmen 700 Series 14x12-inch with black on black mounting. Check out the different sizing and placement of photos to add visual interest. Notice how Ken has used infrared cactus photos to help set the scene.

Pro Shots, a digital service that either scans your negatives or processes your digital files. They then put the images on the web for viewing and ordering. Pro Shots can print a proof magazine with six to twelve numbered images on a page. You can also use their service to design albums online."

Ken uses a variety of different films; color in 400 and 800 speeds, 3200 black & white, as well as infrared, which is used for stylish environmental portraits. He gets a feel for what film to concentrate on in the planning session.

What specific advice does Ken have for photographers? "Show big! You need samples you're proud of, that are complete, tell a story, aren't redundant, and are tasteful. Large, well-made sample albums are the basis of your sales. When you package the big album as an end product, you'll also recognize it gives you a shooting storyboard for what you need to capture on the wedding day. Then you have those elements there to sell. It works hand in hand. You have to have enough different images.

"Use storytelling elements," Sklute continues. "You need an opening, middle, and a close. Photographers often forget about the opening and close and get right to the meat of it. An opening might be an engagement session or some details of where the event is taking place, maybe someone dressing. Closings are often sunset, evening, or twilight

shots. Don't forget various elements—signs, names, flowers, or the ceremony site being set up. Anything people spend dollars on, you want to document because you want to help them remember it. Above all, capture emotion. If you shoot in sequences, you can sell multiple images. Grab that security shot and then wait for the killer expression. Capturing emotion will tell a story, and getting everyone excited will sell images." He also suggests, when designing the album, to try not to mix color and black & white prints on a single page or spread.

Ken's final tip is to use a timeline sheet that covers all of the details of the day. This helps get everyone where they need to be when they need to be there and saves valuable shooting time.

This Sandis Fine Art album is designed with one image to one side with a transparent fly leaf. This type of album can be sold as an add-on to the main album and contains only art prints of the bride and groom.

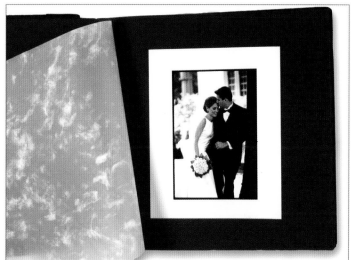

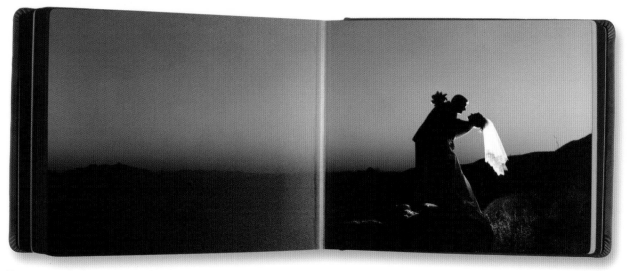

This Leather Craftsmen album features a panorama print. Having an image this large really creates impact.

2. Yervant

"My father was a photographer in Ethiopia," Yervant explained, when asked about his start in photography. "He had a studio and lab and photographed much of the royalty and the Emperor Haile Selassie's requirements. I grew up watching, playing in the studio, and attempting to print from a very young age. He gave me my first 35mm camera for my sixth birthday, allowing me to waste much film over the years." Yervant loved photography and the lab, and was always at the studio after school and during holidays. At the age of eleven, one of Yervant's African landscape prints was entered in a competition. The emperor heard about the print winning first place and extended an invitation for Yervant to visit him at the palace. "I put on my navy-blue suit, wet my hair, and got picked up by His Majesty's chauffeur. The emperor gave me a gold medal."

After high school, Yervant studied fine arts in Venice, Italy, and then attended the Photography Studies College in Melbourne, Australia. He chose to set up business in wedding and portrait photography because he loves working with people. Each wedding gives him the chance to be a portrait photographer, fashion photographer, photojournalist, and landscape photographer all in one day. In addition, he's surrounded with happy people all day long. "What more can one want from a job?" asks Yervant.

Yervant is a highly recognized photographer, as evidenced by the numerous awards he has been granted by the Australian Professional Photography Association (AIPP)—including Triple Master of Photography, Wedding Album of the Year, Wedding Photographer of the Year, Highest-Scoring Wedding Print, and many more.

Yervant markets his business by advertising in the top-end bridal magazines and through his studio location in Melbourne, a mecca for art, fashion, and exclusive bridal couture. In addition, he has a great reputation, which generates referrals. Magazine editorials about his work appear on a regular basis.

"My wife and partner, Anie, is the bridal couple's first point of contact, and it is usually by phone," says Yervant. "An initial inquiry is usually made regarding availability on a particular date. Once this is established, the couple comes in for a personal consultation. Anie shows them a variety of albums, explains pricing, and books a date nine times out of ten.

"Anie's background is in sales and marketing for multinational firms. She joined me in business after our son, Ricky, was born. Anie can talk underwater. She is vivacious, bubbly, and very friendly. She takes a genuine interest in each and every client, and they love her. She is absolutely biased about my work and sells it with passion. She cries with clients

"Keep up with the world. You don't have to be a trendsetter, but see what others are doing and keep up."

over beautiful pictures and laughs with them about funny moments."

Yervant and Anie have set up a very attractive storefront studio with a modern and warm atmosphere that is welcoming and comfortable. Beautiful work is displayed on the walls, with particular attention paid to the way each print is displayed. Prints are all the same size and are framed alike, creating a serene uniformity with vastly different images. There is beautiful background music playing when Anie greets the clients. She shows them many albums, takes them through pricing and sits back and waits for their decision. According to Yervant, "We never sell or apply sales techniques to book a customer. We just show them our photography and relate them to it. If they can see themselves within my work, price is usually not a factor."

Engagement portraits are not highly sought after in Australia. Yervant will do a modern studio shoot in many cases or take the couple outdoors and do candid captures. "I do not like posing my clients," says Yervant. "I prefer to bring out their personality and character in the capture rather than pose them to a typical perfect picture."

The wedding day session starts at the groom's place. Yervant arrives with an assistant photographer about an hour before the groom leaves for the ceremony. He takes casual and detail shots of the preparations, friends, and groomsmen—and pays particular attention to the parents.

"I take many shots with both parents and the groom, then photograph portraits of the groom that are casual, fun, and spontaneous. Afterward, I go to the bride's home. I cover her place much in the same way and then go to where the ceremony is taking place. I cover the marriage ceremony thoroughly, but a big emphasis is placed on what is going on around

The cover image on this album utilizes a very graphic design with stylized type and a flower close-up. The photo(s) selected for the cover help to personalize the album.

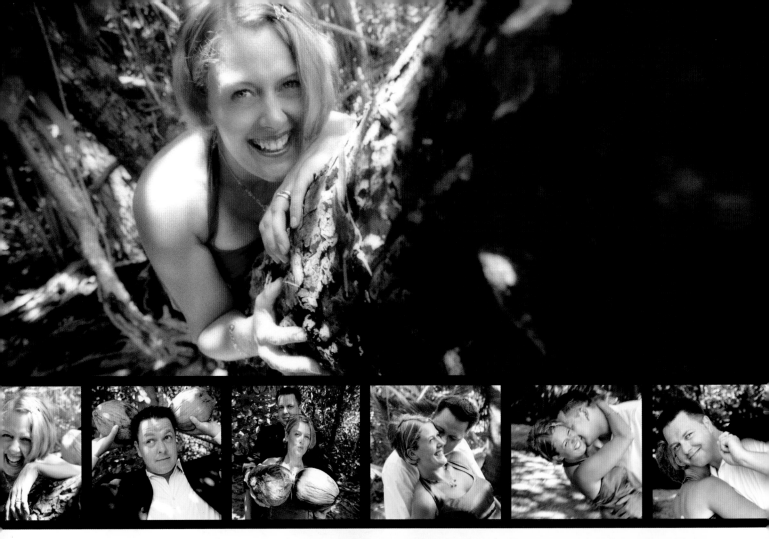

the bride and groom; for example, I capture the parents' emotions, friends' expressions, little children and their behavior, details of decorations, details of the location, flowers, attendants—everything and everybody that make up this special day. I virtually have eyes behind my head and try not to miss anything." Yervant's assistant will do the same, and they end up with a coverage of stills as if they had videotaped the day.

After the service, Yervant photographs the family formals then proceeds to have some fun with the bridal group. "First, I will take them to a bar or coffee shop to relax and buy them some sustenance. It's

Albums Australia printing and binding help to create good looking albums that tell a story with multiple images on a page.

amazing how quickly they become real and almost forget I am holding a camera and shooting while all this is

going on. Then I take them to locations, choosing scenes that suit the couple. A modern funky duo is well

suited to little alleyways and graffiti-filled spaces, colorful walls, and city streets—fun stuff. I encourage them to dance and party while I take shots.

A classical or quieter couple is better suited to romantic locations like the beach, bluestone buildings, and classy cafés.

Sequences of images help to turn individual frames into a cohesive storyline that captures the excitement and emotions of the wedding. To create spontaneous moments, Yervant encourages the couple—and the wedding party—to play to the camera.

"On her wedding day, the bride is at her best. She's happy and radiant. I ask her to pose like a fashion model and she goes wild! She plays to the camera, laughs and giggles, and has a ball. The groom adores her and is absolutely taken by the moment. I turn the camera on him too, and their bridal attendants as well. People in the street watch, and the couple become even more excited. They have a crowd of people loving what they see. They pose more and play to the camera more. I am taking these photos and capturing the crowd's reaction. That is the day: real stuff, real people, and unexpected moments."

Finally, they go to the reception venue, and Yervant and his assistant photograph details of decorations, the bridal couple within the venue,

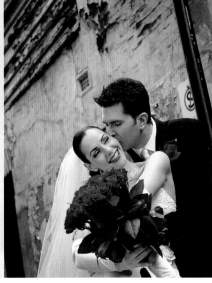

the cake and cake-cutting, and anything else that the bride and groom wish for, including Uncle Harry and Auntie May. Then they call it a day.

Yervant averages 600 to 700 shots throughout the day, shooting mainly digital, while his assistant uses film. He was one of the first to start using a digital camera at weddings and loves the results. Images are downloaded and edited the same night. Files are sent to a lab to print a page layout of twelve images. Some images are illustrated in black & white. Each image is numbered, and pages are mounted in an attractive album and presented to the couple as soon as they return from their honeymoon. The couple will take this album home and choose fifty to sixty or more images. An appointment is made to design their album.

"Anie or I will spend over an hour with each couple, going through their choices," says Yervant. "We first establish the style of album they require, i.e., Story Book or Traditional (photos in mats). We go through the images and the couple's choices and finalize a list. Most couples trust me to design their album, then come see a layout for approval. Some request small changes. As most of my album sales are for the Story

Graphic elements, such as the stylized font and layered images, add interest to Yervant's albums.

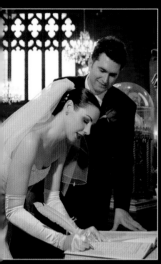

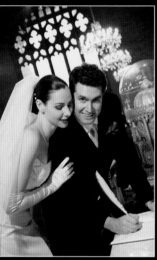

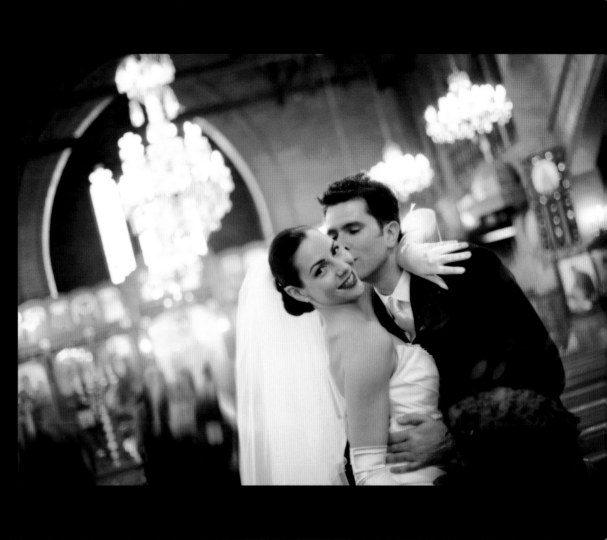

In this spread, a large image offsets two smaller ones.

Book album, couples have booked my studio for the very product. Having chosen favorite images, they leave it up to me to create their story."

Every couple is given a component-based price list. This allows clients to pick and choose any combination of product that is offered. Some couples just want large wall prints, not a wedding album. As long as they meet the minimum purchase price requirement, Yervant allows them to buy exactly what they want. Every couple is offered payment-by-installment from the day of booking;

it is easier for most couples to pay the total over a twelve-month period.

"I use Albums Australia, the best album manufacturer in Australia," explains Yervant. "They now have rights to use my Story Book Layout Templates as part of their album planning software (Yervant created the software to set up the magazine-style album pages); this provides other photographers worldwide the opportunity to make my style of magazine albums."

It takes Yervant around six months from the date the order is

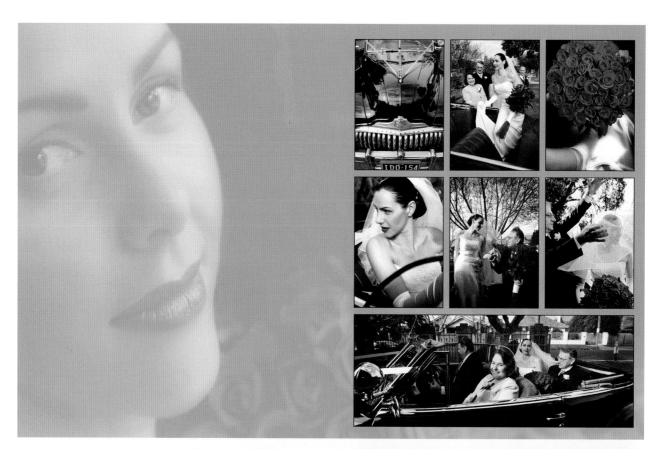

This Page and Facing Page—Using ghosted images adds both texture and depth to magazine-style albums. Albums Australia also offers a page layout program to help speed layout and design.

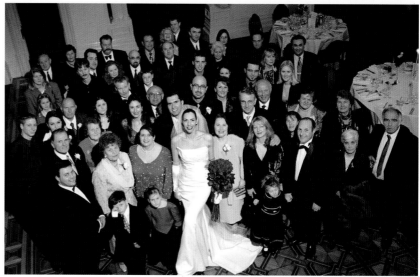

placed to deliver the finished product. Once all images from film are scanned, cleaned, and retouched, the page layout is created and the couple is invited back for a preview. They can do any type of change at this stage. Final files go to a Lambda printer [a printer that prints digital files to photographic paper], and then it is time for album assembly.

Yervant's advice for photographers is, "Have fun doing your job. If you don't, the results show it. I think it is most important to be on the ball with new technology, new products, and trends. Read magazines and books, look at other photographers' web sites, go to seminars and exhibitions, watch fashion magazines, study art books, and look at other photographers' storefront windows. Always be aware of what is going on out there beyond your suburb, state, or country. Keep up with the world. You don't have to be a trendsetter, but see what others are doing and keep up. Enjoy what you are doing, and if you start calling it work, get out and do something else!"

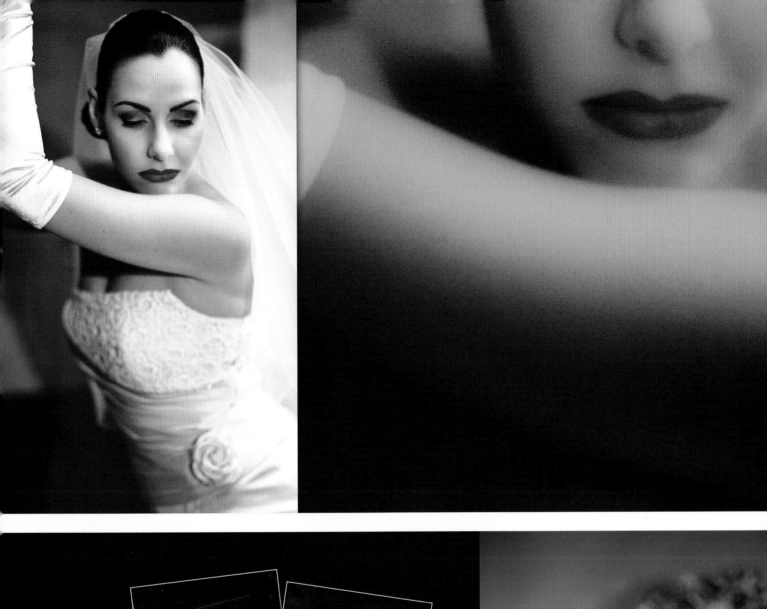
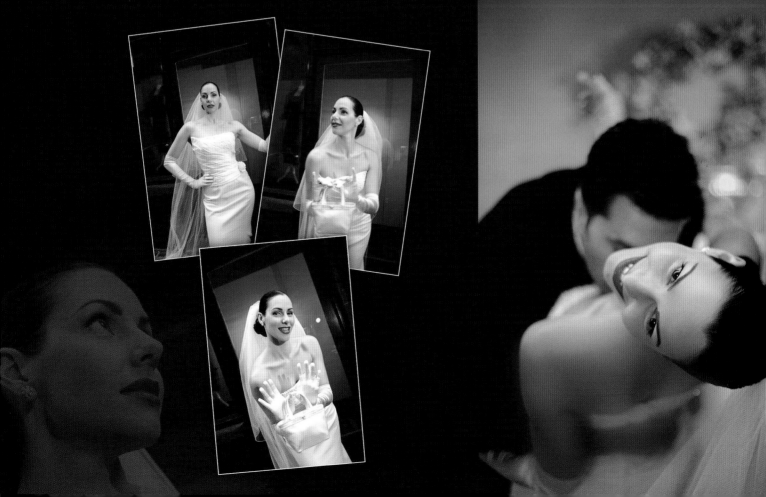

3. Andy Marcus

FRED MARCUS STUDIOS, NEW YORK, NY
WWW.FREDMARCUS.COM

Andy Marcus grew up with wedding photography. "My father started the business in 1941. I came into it when I was thirteen years old, assisting him with weddings. After about four or five years, I started to shoot partial weddings. I already knew how to pose people and set up lighting. I never really went to school for it; I just picked it up from watching my father." Marcus uses the same technique to train photographers who work for him now. He feels it's really a learn-by-doing thing.

Andy holds Master Photographer and Photographic Craftsman degrees from Professional Photographers of America. He has also authored a book published by Amherst Media—*Wedding Photojournalism: Techniques and Images in Black & White*. He speaks on a variety of subjects at national and local photography conventions. He has written many articles, and others have written about his work in major photography magazines and in almost all major bridal magazines.

"Most of my calls are from people looking for information, and I always explain to them that it is very difficult to give information about some-thing visual over the telephone. I use the wedding gown analogy: You wouldn't call Bloomingdale's and ask 'How much is a wedding gown?' The answer you'll get is that they have gowns for $2,000 and for $20,000, but that doesn't tell you what they look like. You really have to see them. It's the same with photography. You really have to come in and see the work. That's my first thing, to get them in the door because I know that once they're in, they will see the difference between what I do and what my competitors are doing."

What happens when the bride crosses the studio's threshold? "We sit down and I really listen to what she wants. I ask questions about what she is looking for, what she is interested in, what she likes and doesn't like in photography. Some people have specific ideas; others have no clue. I get a feeling for the wedding—location, outdoors or indoors, formal or informal—and then bring out sample albums of that particular style. If somebody is having a tent wedding at their parents' home, I'm not going to show a very formal wedding at a hotel. I have albums made for different situations, and that's what I show. I must have fifty samples, both in color and in black & white, with sizes from 5x5 to 11x14 inches. Leather Craftsmen is the bookbinder I use.

"We talk to the bride and show her albums," Andy continues. "Then we go over prices, discuss how we work, and what options are available. We start with a basic album and a basic arrangement, which includes a photographer and an assistant and X number of hours." Everything else is additional. Marcus has a list with the costs for additional photographs or

"... the whole schmoozing end of the wedding business is very important. I've seen mediocre photographers who know how to speak well with clients be very successful in the business."

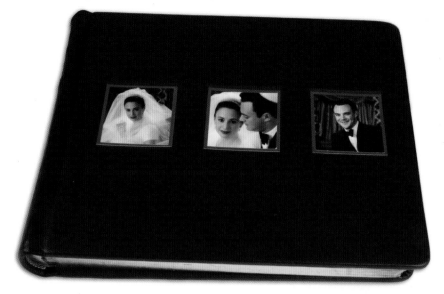

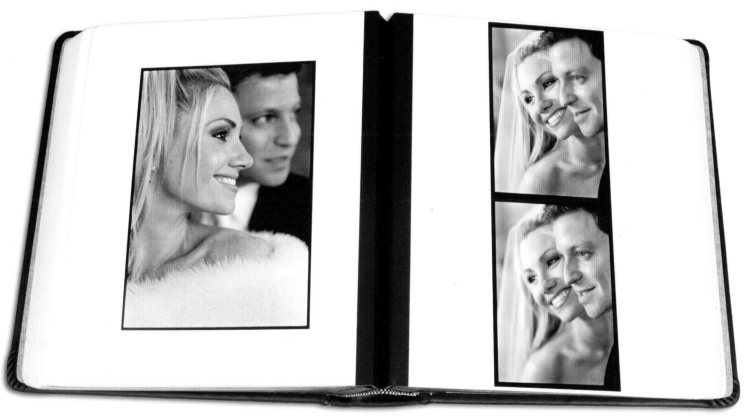

Fred Marcus studios use Leather Craftsmen albums. To the left is a Rustique Black leather cover inset with three 3x3-inch inset images framed with gold. Below is an 8x10-inch flush-bound book with images printed with surrounding white space. This is another way to present images. The white borders and black key lines give the images a gallery feel.

additional bindings if parents want albums or wall portraits. The list is based on time and materials, but he doesn't mark up for materials. With seven full-time photographers, including Andy, he does charge differently if he shoots the wedding himself rather than assigning it to one of his associates. The company's written price list is revised every year.

Once a bride has signed up for the studio's services, Andy gets a reservation fee from her. He makes an important distinction between a reservation fee and a deposit. "A reservation fee is not refundable; a deposit is refundable. Nonetheless, if something happens and a wedding gets cancelled, I normally return the reservation fee immediately. I feel even though it is an inconvenience to

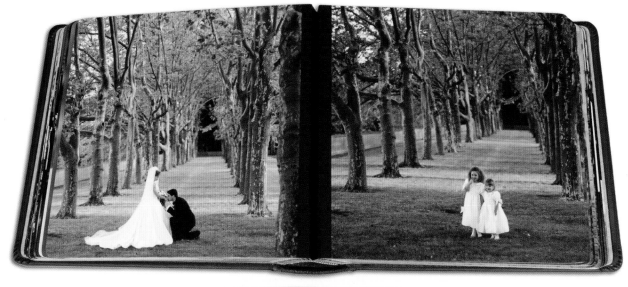

me or I won't be working, once the bride does get married she will use us for her pictures. She will appreciate that I returned that fee, but holding the fee is always an option—especially if the cancellation comes at the last minute."

On the wedding day, Marcus arrives at the wedding site already knowing where he is going to work; if it is a private home or somewhere he's never shot, he will go an hour early and scout where to photograph. "I have an assistant with me always.

While I'm checking things out, the assistant is setting up equipment, lighting, cameras, and loading film." The next step is to find the bride and start to photograph. Andy's shots are different depending on whether black & white or color is used. "I usually photograph people getting ready in black & white. I've never had a bride who ordered pictures of herself getting ready in color."

Marcus normally fills a traditional color album with family photographs. "I try to get all the family

Top—In this spread, half-page, full-bleed panoramas on facing pages add a stylistic look to the 10x10-inch flush-bound album. Bottom—In this 10x10-inch flush-bound album, a two-page panoramic photograph is featured.

portraits before guests arrive and before the wedding starts," Andy explains. "This is something I push for, explaining the pluses and minuses to the bride. I do all the combinations of family I need to get done. Even though photojournalism is the big thing right now, and I do photojournalism, I also know that my brides love their portraits, their parents love their portraits, and I would say that 50 percent of what I sell from the day of the wedding is portraits." Marcus feels the biggest reason most photographers who are photojournalists don't do portraits is because they do not know how. He believes if you create beautiful por-

traits, people will buy them. The parents, aunts, and other family members like to have them because it's a record of the family at that particular time in life.

Marcus has a unique way of dealing with "tradition." "I don't get any grief from the bride and groom about seeing each other before the ceremony because I explain the pluses. People appreciate that I am concerned about their enjoying the wedding and not being taken away from their reception for photographs. I schedule anywhere from two to two-and-a-half hours for portraits depending on the size of the family. I like to do it at my own pace and I

Images of different sizes and shapes keep page layouts from being boring. Don't be afraid to experiment. Talk to your album company about different page layout ideas.

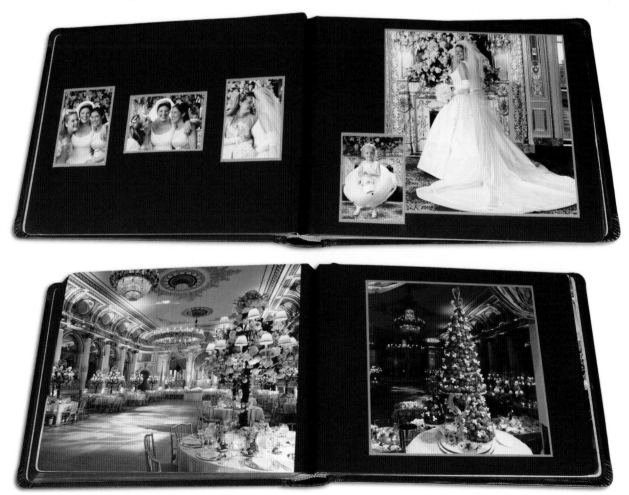

also like to allow a little time for the bride to be late, which she usually is." Andy stresses the idea that everyone should respect everybody else's time. The hairdresser, the photographer, the church, and the banquet people all have their own time. If you take any time away from anyone, the job will not be done properly. He suggests, "If you propose being on time to all vendors in a nice way, people do listen." Using this approach, he's been pretty successful

in ensuring that everything runs on schedule.

As far as capturing the photographs is concerned, Andy says, "I'm on top of things and try to anticipate. I think a good photographer needs to anticipate; otherwise, you are there after the moment happens and you miss it. For example, a good photographer captures the expression on a father's face when he looks at his daughter as they are walking down the aisle. When a bride and groom

Don't forget to take scene-setting photos. People spend a lot of money on these venues and flowers. Here, Andy utilizes full- and ¾-page panoramics to best advantage.

are having their first dance, I always expect a dip at the end. I'm waiting for it, ready for it. It may not happen, but as least I'm there before it happens, and ready."

Fred Marcus Studios average 500 to 700 frames, eliminating five or six images. Andy's father taught him to make every shot count. "When I push the button on the camera it is a shot that I really want to get; otherwise, I don't take the picture. I find that brides get confused with too many pictures. If you give them too many choices, it overwhelms them; it affects orders and the time in which you receive the orders."

Marcus provides the couple with 4x5-inch proofs, which are delivered in an attractive box. He used albums years ago, but they cost $80 to $100, and customers would rip them up or write on them. He now uses a cardboard box that costs only $1.10, which is made from the same material in which their Leather Craftsmen albums are delivered. The box is wrapped in gold ribbon and comes with a set of instructions on how to order. Andy has discovered over the years that people like to lay the pictures out on the table, and says that even if the photos were in an album, people would still lay them out. Marcus doesn't use lab numbering; instead, each proof is numbered by hand and sorted in sequential order.

Brides come to the studio to pick out their pictures. Andy helps them determine the layout of their choices into a Leather Craftsmen album.

When this is put together, most brides really like what is shown. It takes about an hour to an hour and a half to design the album and make sure it has a nice flow. After everything is printed, the studio makes sure all prints have good quality. The bride and groom are invited to come in and see their album before it goes to the bookbinder.

They give a final okay on the sequence and quality of the pictures, sign off, and it's sent to the bookbinder.

Andy recommends that new photographers get hooked up with a high quality studio where they can learn lighting, posing and—most importantly—how to talk to people. He emphasizes that the whole schmoozing end of the wedding business is very important. "I've seen very mediocre photographers who know how to speak well to clients be very successful in the business."

This album features another use of the flush-mount style. Here, the photos were set on a horizontal orientation. It pays to think outside the box!

4. Carlos Lozano

LOZANO IMAGING, MONTEBELLO, CA

I first met Carlos Lozano at a seminar he gave in Payson, AZ. I was immediately taken with his strong knowledge of the business and common sense, which he shared in a very warm, soft-spoken way.

How did Carlos get his start in photography? "My eighth-grade teacher asked me to photograph a school play," explained Carlos. "When she saw the results, she asked me to do three other plays. Years later I was taking night shots of the skyline over Los Angeles, and a lady came over and asked me if I was a photographer. I said, 'Not really.' She asked, 'Do you like photography?' and I replied, 'YES!' She invited me to a meeting with the Los Angeles Photographers' Group. Lucille Stewart was her name, and she took me under her wing, got me to join and be active."

Carlos's wedding photography background spans thirty-one years. He's run the gamut throughout his career. "I had a wedding photography studio that employed as many as eleven photographers. In 1979 we did about 320 weddings. I found myself being a manager more than a

photographer, which I hated. In the early '80s I cut it down to me being the only photographer, doing just one wedding a week."

Carlos shares his knowledge of photography with others, presenting programs at state and national conventions as well as the West Coast School of Photography. He has won numerous awards for his portrait and wedding work, including being named Photographer of the Year twelve times. He holds the Master of Photography and Photographic Craftsman degrees from PPA.

How does Carlos get his work? He does the occasional bridal show and markets his studio by placing his photography in key business locations. He illustrates how important it is to do a good job when he explains, "More than 95 percent of the weddings I do are referred from weddings or families I've photographed."

On presenting the studio to new clients, Carlos says, "We don't sell photography. We sell ourselves. Years ago I found everyone is selling photography. Instead, if you sell yourself, resistance to price is lessened. I won't say it goes out the win-

dow, but it is lessened. Couples are willing to spend more than they think they can afford."

Lozano does a photography session before the wedding. "Most of my clients prefer that," he said. "My couples are in their very late twenties or early thirties, right out of college or into their professions. They want to enjoy the reception they are paying a lot of money for." Rather than spend two or three hours with the photographer and miss that reception, they go to the studio before the wedding, do a full session there, then move to an outdoor location and cre-

"We really get the bride and groom involved in doing this. The reason is not insanity. It sells."

 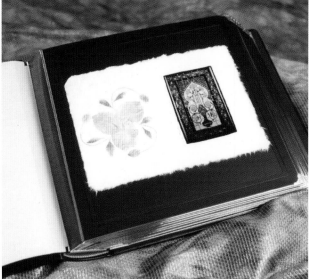

Left—This is an Art Leather Behind the Scenes cover, usually black, but may match color album. Right—The first page usually shows the mood or feeling of the wedding location. All prints are 3¹/₂x5-inch sloppy-border sepia tone images. In addition, a select few are hand-tinted.

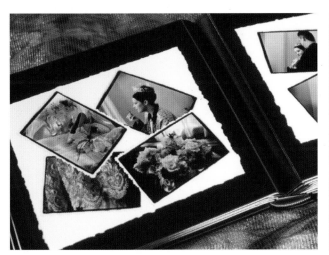 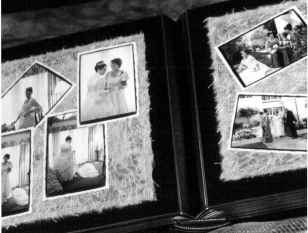

Left—The use of watercolor paper with hand-torn edges gives the prints a different look than those mounted on black pages. Right—Fine Japanese rice paper gives a lacy quality to bridals.

ate some fabulous shots. On the wedding day they don't leave the reception. Carlos is then free to follow them around and shoot photojournalistic and fun shots.

This has worked out so well for him that his clients expect it. "I can't remember the last time I had resistance to that system," says Carlos. "The only type of resistance we've had in the last ten years is lack of time, where the groom is flying in from back east on Friday and out on Sunday. There have been a few weddings where we haven't worked ahead of time. With those, it's arranged so we start photography four to five hours before the ceremony."

Lozano has an interesting way of getting around the bride and groom not wanting to see each other before the ceremony. He tells them, "The groom is up front. When the bride enters the church, everyone stands up; what the groom ends up seeing is her head bopping down the middle aisle. By the time she gets to him he's so nervous that she could be nude and it wouldn't faze him. This romantic notion of not seeing the bride pre-

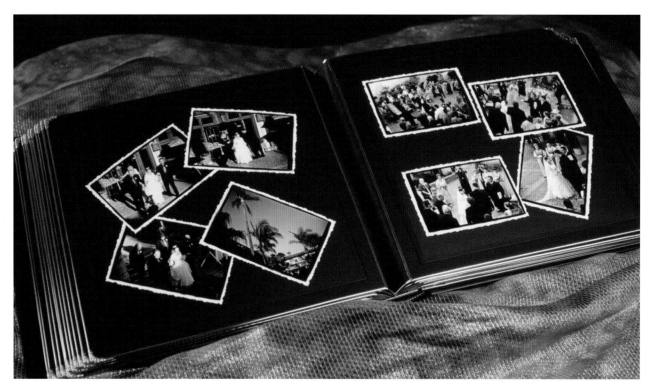

Behind the Scenes album photographs are seldom taken with a level horizon. This allows a different mounting from the color album, yet the images remain upright to the viewer.

vents the couple from having some wonderful photographs taken together." Carlos suggests the groom's eyes be covered, then that the bride be arranged in front and the blindfold removed. Capture the first moment the groom sees his bride. After that, you are free to continue to create images before the ceremony.

Carlos describes his pricing philosophy, "I started with packages, then went à la carte. I did well, but it was confusing to the client. I have basically come back to packages that represent my work. It's a very soft sell, so they buy what I want to produce. If I don't like doing something I price it so outlandishly expensively that there's no way the couple would choose it. If they do, they pay me so much money I don't mind."

Carlos now mixes different shooting styles and has come up with a way to showcase both. "I am a purist at heart," he explains. "I've worked hard to develop my classical portraiture style. Yet I like the black & white photojournalistic look. I don't want one to overlap the other and destroy cohesiveness in the albums. When brides started asking for photojournalism I had a hard time saying yes. I wouldn't do it because I knew it would rip apart my album. That's when I envisioned this new black & white 'Behind the Scenes' companion album. My brides still get my classic color album. They also get a black & white album, which is fun to produce. The bride and groom do not get to see any of the black & white proofs or choose any of the

photos in the black & white album. I put this whole album together personally. Not my staff. I feel good that everything in the album is mine. If there are special effects, hand coloring, or special cropping on those prints, I personally do it.

"On the final consultation before the wedding we make an itinerary of what's going to happen and the last few questions we ask are, 'Have you finalized your choice of colors for your album? Do you want your Behind the Scenes album to match your color album?' Before the day of the wedding, we've already ordered the Behind the Scenes cover." In this way, Carlos is ready to produce this album within days of the wedding.

Lozano uses Art Leather albums, and when the design process begins,

the album cover is already in the studio, engraved with the bride and groom's names and date. Carlos starts with blank pages. "I love working with those. Generally I have three images on each side, so that's six prints per page. I only shoot three rolls of 36-exposure 35mm film. I send that out immediately to be printed as $3^{1}/_{2}$x5-inch images in a sepia tone. I send color film at the same time, but the black & white is generally done way before the color. I go through and edit between two and eight pictures. I compose the storyline and trim the edges, sometimes using pinking shears for a different look. I add coordinating papers and other special touches. Prints are attached using a Scotch ATG700 transfer gun tape. While the color prints are being numbered and put into preview albums, I'm putting together a finished black & white Behind the Scenes album.

"We call the bride and set up an appointment to view the color proofs," Lozano continues. "At our studio, the first time the couple sees the wedding previews they place the order for their color album. Then they take the previews home to show everyone else, but their order is done. After they place their order for their color album we present their black & white Behind the Scenes album. They leave our studio with a finished album." Carlos has found this turns out to be a great sales tool and also lessens the calls of 'Hurry up—I can hardly wait to get my photos.' Brides start showing it to everyone. People say, 'You just got married a few weeks ago. My daughter's photographer has taken a year and a half.'" Carlos explains, "Actually, the daughter has taken a year and a half to place the order, but Mom's not saying that, she's saying, 'My daughter's photographer . . .' So what happens with our studio name? It's a couple of notches up from other studios because clients are looking at a finished album shortly after the wedding."

When asked how he charges for his photography, Carlos replied, "I don't sell by the image. I sell by the size of the album. My small package would be an album of forty-five images; medium would be eighty-five. We start splitting our albums there. We don't like having the big thick albums. Our large package is three volumes with about forty images in each.

"We warn our couples the day they come in to place their order that we could be in the studio between two

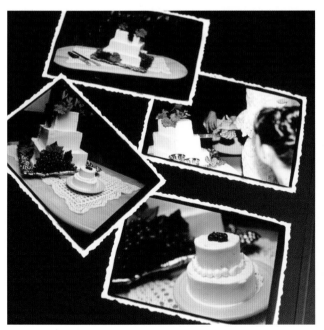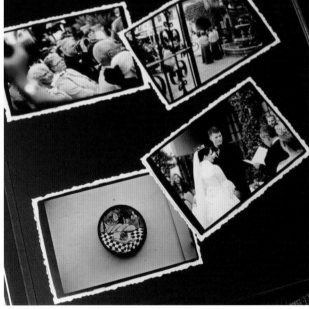

Left—The cake is often represented by one photo. Brides take time to choose it. Show different views, whole and partial. A close-up of the cutting makes a good end to that page. Right—Some prints are cut with art scissors for a fancy-edge look, but don't do all of them that way.

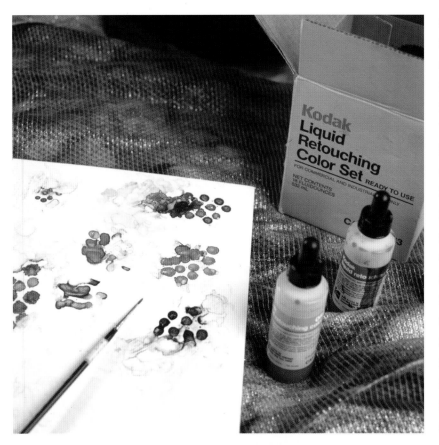

and four hours. The album is going to be their creation, not ours." Carlos stresses it's very important that the couple does not get their proof images until this process is complete. The more times the couple get to see the preview album the less chance of a good sale, because they start getting used to the images. "We have a map of the different layouts the couple can use on various pages," Carlos continued. "We really get the bride and groom involved in doing this. The reason is not insanity. It sells. The couple is going to decide what goes on the cover and then what goes on the first page, second page, etc. At the end of that selection we do the tally. We don't do the tally until we are absolutely certain that it is the story they're going to be extremely happy with for the rest of their lives. Once they are agreed on that, there are very few people who will say, 'No, no, no—cut the number of images in half.' The story line will fit together, showing their very important day. They don't want to ruin it.

"Do they pay for everything right then? No," Carlos says with a gleam

Top—Hand-tinting is done using Kodak Liquid Retouching Dyes. Carlos makes a palette, dropping a few drops and letting them dry. A sable brush dipped in distilled water is used to pick up the color. Carlos suggests pastel rather than strong color. Kodak dyes dry without a ring and do not require spraying. Bottom—Paper is purchased in an art store. Most albums have two to five pages with paper underlay.

in his eye. "Up until then, they have paid for whatever package they selected in full before the day of the wedding. They have selected all their images, and it could be several thousand dollars over what their plan was. No matter how well I did in my photography I'm not going to win over the basic things they need like a refrigerator or furniture. So when they go over that thousand dollars or whatever it is, I don't say 'you have to pay right now.'" That's when Lozano becomes the nice guy and he tells them, "I realize that this is quite a bit over what you thought you would be spending. What if I break this down in payments? Would twenty-four months be comfortable for you?' Now he's made it possible for them to have their dream package. What else has he created? "Cash flow," Carlos says with emphasis. "They've already paid a large chunk up front. That was my working capital. I'm ensuring cash flow for the next fifteen to thirty months. I deliver the album at the end of that time."

In his Behind the Scenes albums, Carlos captures the flavor of the location by paying attention to all of the details—like the light fixture shown in the bottom right photo, which he photographed from the floor up.

use to advertise in publications. "We want to capture the day as it happens and not stage it." Jeff likes clients to know that they can be themselves, and he feels people photograph better when they don't know they are being photographed.

If the couple wants posed pictures, they take advantage of what the Hawkinses call "Private Time." Many couples indicate they want a lot of candid photography, with very few posed images. While they just don't want to mess with it, they do realize they need to have some posed photographs made. "For this we devised Private Time, which is a very powerful experience. We realize that the groom does want a 'big production' first look at the bride in her gown. I really get passionate about this," Jeff enthuses. "I show couples what they are going to be experiencing, and most will agree to see each other ahead of time. Private Time has become a very positive, very memorable experience for the groom. He sees the bride come into the room, and she looks the best she is going to look all day. We then create all posed pictures before the wedding, and it's finished. Then the couple can go about enjoying their day without worrying about having pictures taken afterward." Jeff tells couples to allow at least three hours before the event for Private Time, because they have to tuck the bride away approximately thirty to forty minutes before people start arriving.

"We shoot between 800 and 1200 images," says Jeff. "We are 100 percent digital." Digital capture allows the Hawkinses to present a wedding-day slide show of images captured

Left—This Art Leather album features a cover with a 5x5-inch inset photo. Below—Album spreads showcase everything from the stars of the day to the little details.

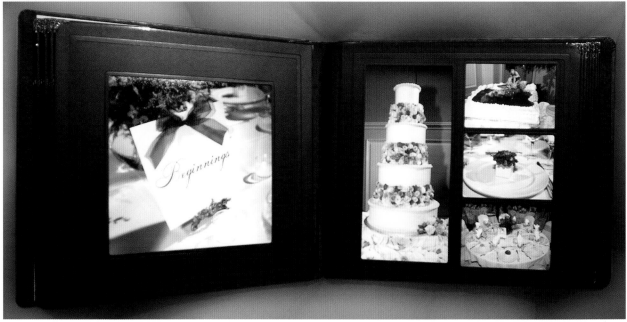

earlier. Jeff's assistant will create a slide show through a program called ACDSee. The couple can select to have the images displayed on a laptop or LCD projector. "Most go the laptop route, since we can be very unobtrusive near an entrance and people can gather around. It is a very positive public relations tool."

Jeff Hawkins Photography currently proofs on videotape. "We provide the couple with three digital proofing videos," explains Jeff. "That's a slide show on videotape. There's no music because these things are usually an hour to an hour and a half long. It is a very simple slide show; each image has a number attached to it, and that is what the couple is going to order from. (The videotapes are grandparent-friendly, with very large image numbers!) We provide order forms with each video. We also use online proofing and ordering and have found that it is more popular than videotape. We will eventually go the CD/DVD route, but right now we are using the videotape because too many older people have no idea what a CD is, and we don't want to exclude them."

Kathleen sends an e-mail to the couple while they are still away on their honeymoon. When they return home, they check their messages and see "Hope you had a good time on the honeymoon. It is time to schedule your album design." Many times that appointment is scheduled a week before the wedding. The Hawkinses try to get them in as quickly as pos-

Top—One 6x8-inch print is paired with two 3¹/₂ x5-inch prints. Bottom—One 6x8-inch print is presented on parchment endpaper. Note the edges on the print.

sible to maintain their production schedules. "The great thing about digital is that we can photograph a wedding on Saturday, design the album on Tuesday, and have it in production before they [people from out of town] even leave the area. That's exciting!

"We primarily use Art Leather albums, with Montage Pro software for album layout. We also use DigiCraft books for a magazine-like storybook. We find that by offering our brides these different products, we can increase our sales. Even when they get DigiCraft books, we always encourage them to get the Art Leather as well, thus providing a classic album and a more unique storytelling album.

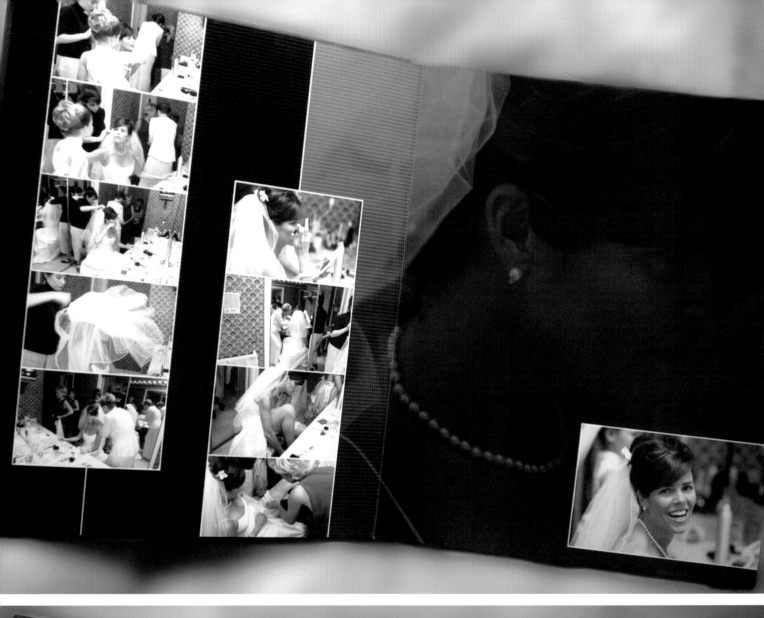
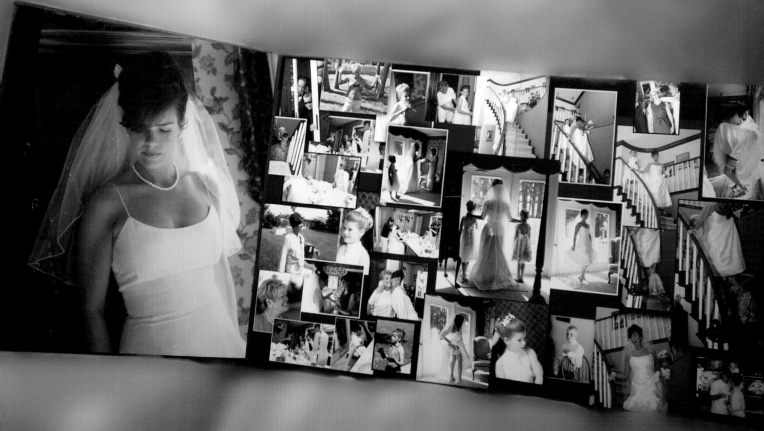

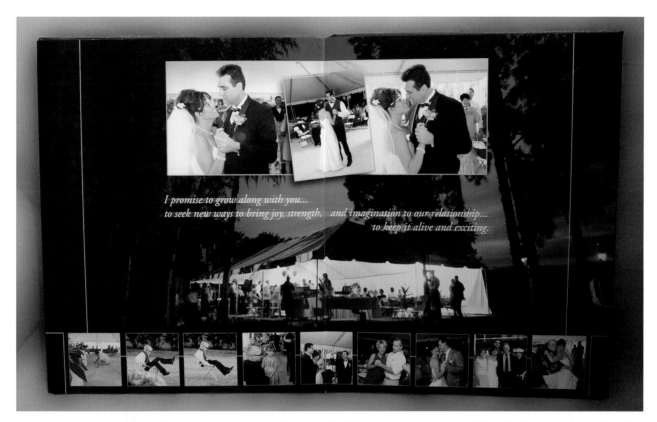

I promise to grow along with you...
to seek new ways to bring joy, strength, and imagination to our relationship...
to keep it alive and exciting.

Above and Facing Page (Top)—DigiCraft album spreads featuring 13x19-inch magazine-style layout. Facing Page (Bottom)—DigiCraft album with magazine-style layout featuring one foldout page. The album can also be designed with two foldout pages.

"I think a lot of the success of our sales can be attributed to Montage Pro," says Hawkins. "I've been a beta tester for several years and if you don't have it, you are losing out. It allows us to lay out true storybooks. We sell two- and three-volume sets because the bride gets to see the layout. Great mats, along with different colors of books and materials, give the bride a lot of choice. She gets to see the design process. When she gets her album, it's exactly what she wants. This raises our sales average from $1,500 to $3,000 above what the couple initially spent. We lay out the books first; then they come to review it. I lay out a lot more images than what they originally selected. We let them know from the minute they walk through the door that we are going to help them design this book and not leave them hanging. We realize that this is going to be a family heirloom, and we want it to be as complete and as professional as possible. Once they see how the photographs lay out, they want it.

"I think you have to educate yourself," says Jeff. "Know your competition. Don't come into an area and underprice everybody. That's doing a disservice to the whole industry. Call around and be up front with it. Introduce yourself because some of your best referrals come from your competition. Work on your style and decide which way you are going to go. With today's technology, the digital route is really an ideal way of working, because it allows so much more freedom and creativity. Don't just be a wedding photographer; be a wedding artist."

6. Heidi Mauracher

HEIDI MAURACHER PHOTOGRAPHY, SANTA BARBARA, CA

WWW.HEIDIMAURACHER.COM

"In 1989 I took my very first trip to Las Vegas and the Wedding and Portrait Photographers (WPPI) convention at the Tropicana," explains Heidi Mauracher when asked how she got her start in photography. "I walked down the hallway, and I was just mesmerized by how many people could do awesome photography. I didn't know anything about photography. I was there by myself and totally overwhelmed. Monty Zucker and David Ziser were the first photographers I met there. I was blown away. That was the year I said, 'I want to do photography.'" Before that, Heidi had dabbled with 35mm and was a full-time lab technician and printer, printing color and black & white each for three years. She had been exposed to photography but had never done any shooting professionally. One day in 1990, the lab owner called her into the office and said, "Heidi, you are one of my best printers, but I have to let you go. I see you distracted and becoming more and more unhappy about being a printer. You want to be a wedding photographer. You have that itchiness and drive to get out of here. I'll give you two weeks' severance pay. Hit the road and do what you really want."

Heidi enjoys sharing her photographic knowledge and has presented programs throughout the world. She also fares well in competition. She has won numerous awards for her images, including two photographs that scored a perfect 100 at WPPI. In 2002 she won a Grand Award at WPPI with a wedding album that also scored a 100. She holds Master of Photography and Photographic Craftsman degrees from Professional Photographers of America (PPA) among others.

When asked about marketing, Heidi immediately replied, "My strongest source of business would be networking with other photographers, caterers, and various vendors in the industry. My competition is not other photographers. It's the florist, caterers, and hotels. The idea is to be in good with them. Know them, work with them, and provide them with image samples." Maintaining a great reputation is very important. Heidi feels that once the wedding day arrives, she is part of a group of people who are serving the bride and groom. Mauracher has a very strong referral list and doesn't do a lot of advertising. She has given up the bridal shows because they don't attract the right type of bride. "I do have a Yellow Pages advertisement," she says. "This works very well for out-of-town people. I live in Santa Barbara, which is pretty well known as a resort area, so I get a lot of out-of-town clientele. I honestly don't push very hard because I don't want a lot of weddings. I want to spend a lot of time with each couple." Heidi only photographs fifteen to twenty weddings a year. With a smaller

"I like to have people look at and invest in my photography as a luxury. It's both a luxury and an emotional investment."

number of weddings, each album is more refined, personalized, and artistic than would be possible doing fifty weddings a year. In fact, Heidi spends many, many hours carefully photographing and then designing her unique, personally-autographed one-of-a-kind albums.

In Heidi's first consultation with the bride, she determines how important photography is to her client. Has she visualized what she wants? "My goal is to help encourage her, work with what she has, and give her more information. I give her tools to be creative. I want to inspire her. My philosophy is to encourage, inform, entertain, create, inspire, and make her really excited about this investment. The more involve-

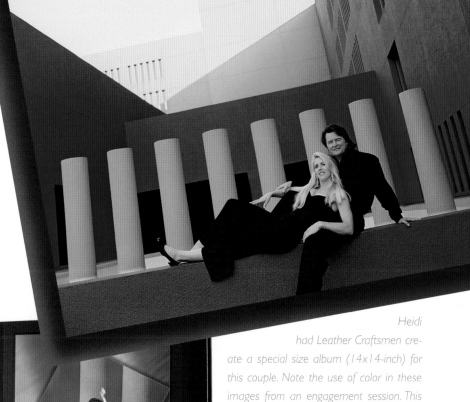

Heidi had Leather Craftsmen create a special size album (14x14-inch) for this couple. Note the use of color in these images from an engagement session. This album scored a 100 at WPPI competition and earned Mauracher the Grand Award.

ment I get from the bride, the more my work becomes a truly commissioned art piece."

To sell the bride on her concept, Heidi shows previous albums. "I show maybe two albums and a few images, but I say to each client, 'What I'm looking for is getting something that is about you. No two weddings are alike.'" Heidi constantly uses the term "commissioned" art to refer to her work. "When you use

Heidi spends a lot of time with her clients. This engagement session lasted all day and had numerous clothing changes.

words like "commissioned art," you give the clients an enhanced perception of their investment," says Heidi. "Wedding photography is an emotional investment, and the more time you put into it, the more treasured and revered it will be—and the more money they will be willing to invest."

Maraucher's wedding-day coverage lasts an average of nine to ten hours. She makes the bride and groom and their families all part of

the team. "We are creating this work of art together. Before the wedding we have the initial interview. We have an engagement session, which is a very important tool. I call it the get-to-know-you session. Before the shoot we discuss theme, locations, and a 'look.' Are we using black & white or color? We want to have a combination of strong graphic design and very romantic pictures—and a variety of locations. I want to get a lot of variety in posing. All posing is orchestrated, but I can't do it without my clients' permission." Heidi's composition and posing go together. If she has a really romantic pose, she's not going to do that under a very graphic structure. "I try to work where everything matches," Heidi explains. "I call it a photo tour and I include both black & white and color, for it gives two different looks, lending more variety to the album."

Clothing is a very important part of Heidi's books. "I mix clothing. Sometimes it will be romantic and then very contemporary. Clothing must match the setting." Heidi lets the engagement session flow. It could be two or four hours. "When I do commissioned art, I don't ever think about how much time I'm going to work with the client. I don't ever give them the feeling that I am going to give them limited time. We want to have enough time to create the story."

Fees are charged on a per-event basis. "I have one set fee for the whole thing," says Heidi. Her philos-ophy is that of a commercial artist—one flat creative fee, and the clients pay for materials. Heidi suggests pricing according to what the market will bear—not what we can afford, but what the fantasy is. "People will pay more for what they want than they can afford. I like to have people look at and invest in my photography as a luxury. It's both a luxury and an emotional investment.

"After an engagement session, where we've gotten to know and trust each other, I like to go to a café to plan the wedding day photography. I like to work in a place with a social

This image was captured with a camera tilt, yet it's presented in the album with the horizon at the proper angle for viewing.

atmosphere because the bride and groom are more relaxed." Heidi steers the conversation to get what she needs to create a really magical day. She needs enough time to create art. "I need them to understand what 'emotional investment' means. I can't do a fabulous photography job with only an hour to do pictures, so I work three hours before the ceremony with a half-hour break. Generally I get all the portraits of my bride and groom

We cast our eyes to the horizons fading light

As we cherish our oceans of love of glowing light.

Holding you tight from dusk 'til dawn,

it is forever to you that I am drawn...

Heidi's use of Photoshop to design pages with complementary backgrounds and bits of text set her albums apart.

and family before the wedding. Every once in a while they don't want to see each other before the ceremony, but I make it such a dramatic thing, I get them to change their minds.

"We discuss the location and the schedule, getting the time line down to fifteen-minute intervals. I usually start the day by going to the hair salon with the bride and getting there a little bit before her appointment. It's nice to get pictures of her getting out of the car and walking toward the salon. I do all this with 35mm black & white film. Inside, I get shots of the excitement and the girls chattering away. The 'anticipation glow' is what I go for."

Heidi then tracks down the boys. "I try to get them hanging out and

Here, a black & white image is set in a vertical letterbox style.

Individual portraits of bride and groom are placed on facing pages. It's a good idea to have the subjects looking in toward the spine of the book instead of looking out of the album.

kicking back, finishing their ties, whatever."

Next the bride and groom have a private moment alone. "I want that to be a very dramatic moment," Heidi shares. "I budget fifteen minutes of quiet time. All the while I'm in the distance using a telephoto lens, just clicking away."

Then the bridal party, moms, dads, and family come in. Heidi utilizes other locations around the venue as well. "I like to have a mixture of backgrounds. It adds variety." She works with an assistant always. "I'm the only one who shoots, but my assistant is there to help me work with a good flow."

Before the ceremony Heidi may add a little black & white of the bride and her father, capturing emotional details. During the ceremony she wanders around as much as possible without being obtrusive. If it is a church wedding, she doesn't go near the altar and shoots using ambient light, never flash.

Heidi does no posed shots at the reception. It's all candid photos and theme-setters. After the wedding day she offers a session to photograph environmental shots of the bride and groom. They head to the beach, mountains, or walk around town. Nothing is set in stone.

Using key lines and drop shadows helps to visually lift and separate the images from the background.

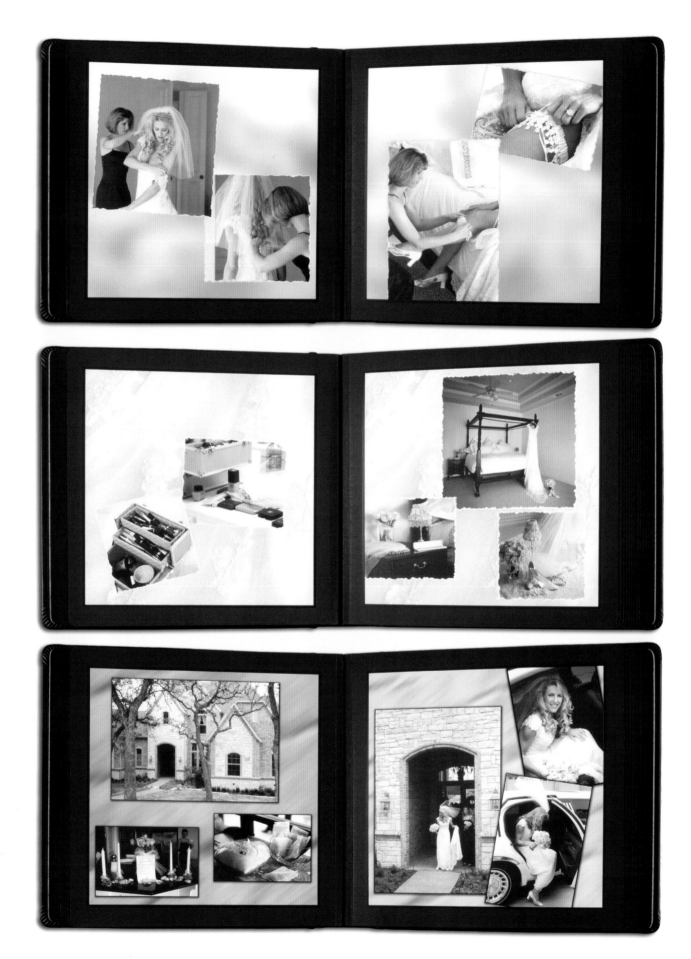

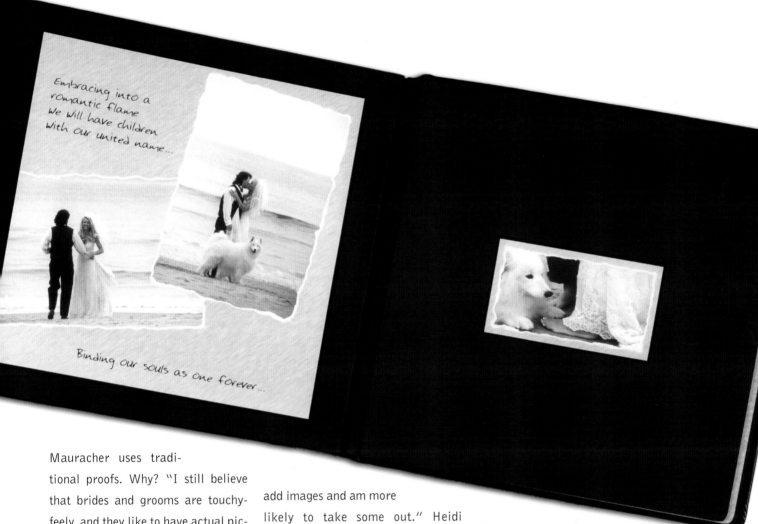

Embracing into a
romantic flame
We will have children
with our united name...

Binding our souls as one forever...

Mauracher uses tradi-
tional proofs. Why? "I still believe
that brides and grooms are touchy-
feely, and they like to have actual pic-
tures in their hands. I don't tend to
work off the Internet; instead, my
proofs are presented in a nice box
from Epic Art."

The couple does an edit from the
600 to 700 pictures presented. Heidi
does the design. She doesn't promote
having the couple present while she
works. "When I put the ideas togeth-
er," Heidi says, "I only use pictures
that are powerful and strong. I rarely

*Facing Page—Black & white images in dif-
ferent styles, shapes and sizes shows that
albums don't need to be boring. Above—
Using a small image on a large page is an
effective way to bring attention to the
image.*

add images and am more
likely to take some out." Heidi
designs the album on a pad of paper
with a storyline and she gets high-
resolution scans that are numbered
according to the design. Then she
uses Photoshop to lay them out page
by page. "Use Photoshop as a good
tool," she advises. "Keep it clean.
Don't make it gimmicky." She ends
up with an album of forty to fifty
pages. The project is completed using
only Photoshop prints or sometimes a
mix of Photoshop images and analog
prints.

"I use the reversible 800-series
book from Leather Craftsmen. I pre-
fer having the border because I feel
that it frames the images. The album

is then purchased by the
client at the cost of the materials."

Heidi's advice for the budding
photographer is this: "Don't get too
wrapped up in photojournalism.
Learn some classical posing. Learn
how to find the light. Without the
light, photojournalism and posing
look terrible. Don't price yourself
low. Don't try to undersell the estab-
lished photographer by charging way
too little. You will only hurt your
chance to make a good living from
photography in the long run."

7. *Michael Ayers*

AYERS INCORPORATED, LIMA, OH

WWW.THEAYERS.COM

Michael Ayers got his photography start back in high school. He was going out west with the Boy Scouts at the Philmont Scout Reservation in New Mexico and wanted to buy binoculars, since the views were so spectacular. His dad suggested a nice camera instead; not only could he look at distances with a zoom lens, but with a photo he could remember what it looked like forever. "I bought the camera," says Michael. "The next thing I know, I'm doing stuff in college for the Ohio State University newspaper for fun. A friend asked me to photograph her wedding because the photographer cancelled. I was a civil engineering student at the time and didn't really want to, although I finally agreed. The bride said I did a wonderful job, but I realized just how little I knew about wedding photography. Between semesters at Ohio State University, I went to the Winona School in Chicago to learn more about photography.

"I began wondering, do I really want to sit behind a computer the rest of my life, since engineering work was changing from drafting tables to computers." Michael explains that he liked the interaction with people that came from photography. He could also be his own boss. "Now, eighteen years later, I sit behind a computer for what looks like the rest of my life," Ayers laughs. "I haven't touched a roll of film in about six months, and I couldn't be having more fun with some of the digital things we are doing. They're changing my life and changing my clients' lives to the point where our work is indispensable to our clients."

Michael has received numerous awards for his photography and album design, the highlight of which was the 2001–02 International Photographer of the Year Award from WPPI; he was also the recipient of the 2001 United Nations' Leadership Award. Ayers and his unique techniques have been featured in numerous magazines, and he has personally shared his techniques with over 10,000 people.

How does Michael capture his digital images? "I'm using a Fuji S1 Pro and Fuji S2 Pro, and I really like them. Are they best digital cameras in the entire world? Arguably not. Are they the best overall considering price and that they're loaded with features? If I drop-kick a camera hard enough I'll go out and get another one because they are reasonably priced! I've made up to 30x40-inch prints, so why would I need something better?"

How does Ayers acquire his business? "Almost everything is referral. We haven't advertised in thirteen years. I do hand out business cards, but I don't consider that advertising; I consider that a contact method. Many of our brides hear about us because I hand out wallet schedules

"There is no 'good,' 'better,' or 'best.' If my clients choose the bottom of the pricing scale, they still get the best photography we can offer."

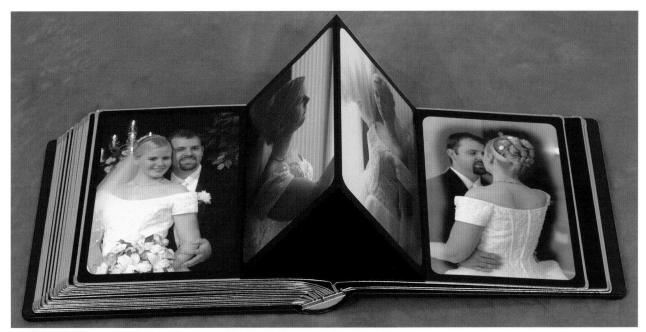

Pricing at the Ayers Incorporated Studio is straightforward. "We give them a final price up front," says Michael. "We tell them what they are going to spend, grand total, unless they are dreaming things up that they want to buy, such as a gigantic wall portrait. While I'd love to sell those, most people don't buy prints that large; it happens—but not very often—at least not in the Midwest." Michael makes a strong point here in his studio's philosophy. "There is no 'good,' 'better,' or 'best.' If my clients choose the bottom of the pricing scale, they still get the best photography we can offer. We stress that each couple will get top-quality images no matter what they spend.

to our clients and they give them out. Their picture is on it and on the back is my business card. I also have my web site listed on everything."

Ayers's first meeting with the couple starts with talk about what they are going to spend. According to Michael, "When clients see the quality of our work and our customer service, if they can get over that hurdle of price, they are ours. We do give them some information on price over the phone, because I don't want to waste time once they are in the studio. When they see an album, though, chances are they are going to be signing up with us." Ayers stresses that the couple isn't just buying photography, they are buying service. "Once we get one bride in the family we seem to get all her sisters as well."

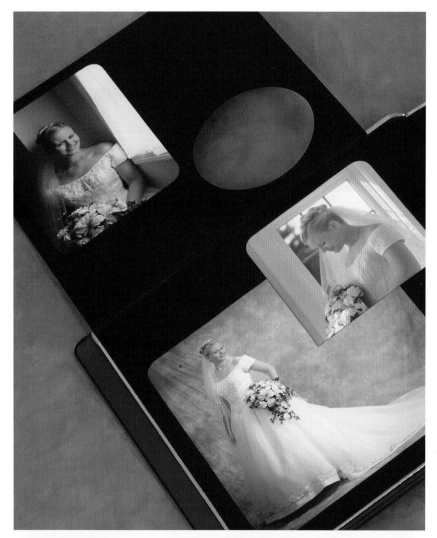

They get everything they would expect to get from a great wedding photographer, even at the lowest price range." The Ayerses' coverage ranges from five to eight hours, and they are usually there for the duration. If the couple is planning an all-day, all-night wedding, the lowest price range is not available. "I've been fortunate enough to photograph weddings in twenty-four states in the past three years, but most of our weddings are typical weddings in a church with gorgeous receptions. The difference in the price is in the type of album we deliver. All the albums are the best that we can deliver; some are just simpler than others."

After talking price, Michael shows the couple sample albums, which are just like the albums going out the door. "They look at the albums and, even if they don't want such an elaborate album, they know that creativity abounds in this place and that's what we are after. Then it's time to talk payment. We've got them in the door. We've got them reserved. Our policy is that everything, absolutely everything, must be paid for in advance. If it isn't paid for, it isn't reserved. We give little incentives to pay early. Anything we give away is designed to help the studio. For example, a hundred free wallet pho-

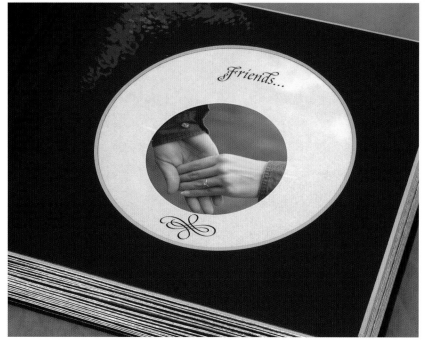

tos would have my name and address on the back.

"I design my album in the view-finder as I create the photographs. I decide how I want my pages to look, what I am going to have fold open, or where the crease is going. I picture every little last detail about how I want this to look as I create the images in the viewfinder. The images are made for specific architectural reasons in the album."

Michael uses General Products as a base for his pop-up albums. After the albums return from the binder, the construction of special features begins. The adhesive for his unique pop-up assemblies is made by Coda. It is a dry adhesive, acid-free, and archival.

Michael Ayers runs a home-based studio where everything is construct-ed by hand in their production room, one step at a time and one page at a

Top—This album shows an example of a diagonal fold-out page. Left and Below—Here, double fold-out pages are used to create a dynamic album.

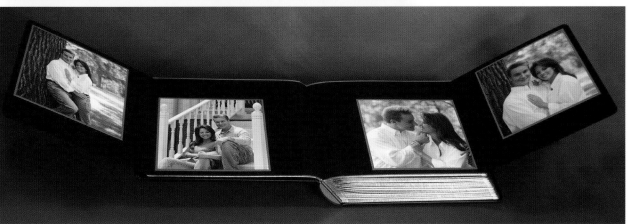

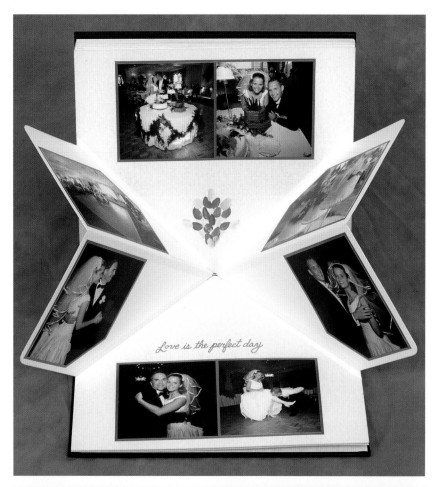

These creations take time and a new set of skills. If you are interested in this style of pages, contact Michael via his web site (see page 48). He has taught many photographers his unique secrets.

time. Michael likens the area to an operating room with bright lights, lots of surgical-type instruments, different adhesives, and cutting boards.

"When the couple comes to view the finished product, we do a white glove presentation of the album. We use white gloves because we want them to realize how incredibly valuable this book is. This is a priceless piece of artwork. The viewing room has a lot of light, which is designed to keep glare off the album. The clients sit on a comfortable sofa and I sit on a chair right in front of them, turning the pages of the album. By the end of the book, they are usually crying. Then I know I did a good job, which is extremely satisfying. After the presentation we box it up and carry it out to the car." When they leave with their album, Michael plants the seed for more sales. "We let them know that this is just the beginning. We want to be photographing their family album one day."

One other idea that Michael uses to set his studio apart is to name every album. They choose a special name for each one; they have been doing that for many years and have never had the same name twice. Usually the couples come up with names like "Magic," "Love Is," "King and Queen for a Day,"

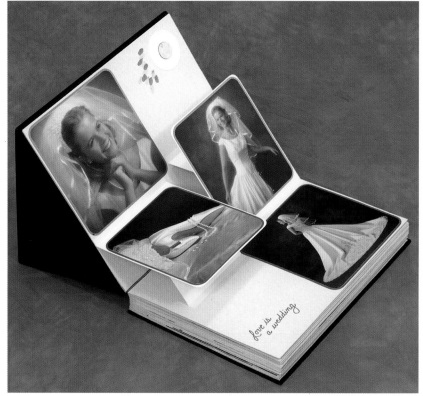

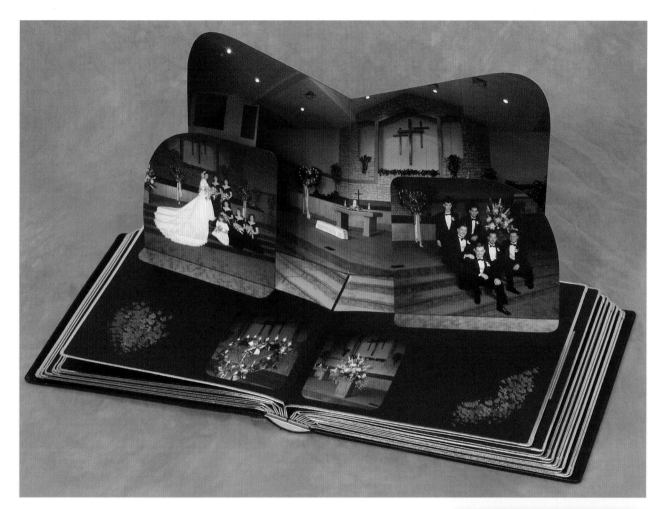

Above—In this layered stand-up album, the bridal party seems to emerge from the altar of the church as the spread is opened. It's a dramatic presentation that draws viewers into the album. Right—Creating these unique pages requires not just creativity, but also a bit of engineering. Here is a close-up of one of the special hinges Ayers has developed to support his images.

"Friends," "Everlasting," or "The Color of Love." "Sometimes they let me come up with the title," says Michael. "We got the idea because Stradivarius named every one of his violins and cellos, and no two were ever named the same."

Ayers's advice for fellow photographers is to write down their goals. He personally keeps photos of his wish list—whether it's a new house, piece of equipment, or new car—posted in a prominent place. The pictures and written goals help to keep him focused.

"Go to some of the weeklong schools like Winona (in Chicago) or the West Coast School of Photography." Michael continues, "Go every year until you are proficient in your photography. The classes I took at the university level at Ohio State were a colossal waste of time. But the people who are teaching at the weeklong schools are some of the very best. Also, if you can afford to,

go around the country to attend more than one."

Last, but not least, Michael says, "Never take advice from people who are not where you want to be. Make sure they are making it financially. Be the best you can be and be all you can be!"

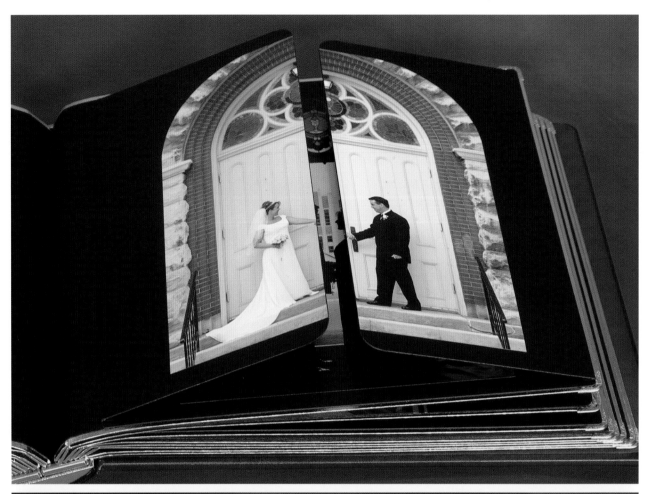

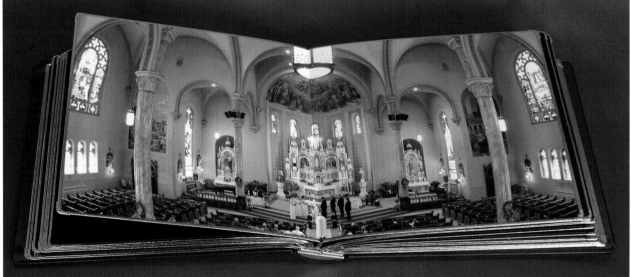

Top—Ayers calls this an "open doors page." When the doors are opened by the viewer, a scene from inside is displayed. Bottom— Panoramic pages are also used to capture the majesty of interior scenes.

Top—Mats can have shapes other than square and rectangle. In small amounts the use of a special cut-out can enhance your album. Bottom—This pop-up folio combines the width of a two-page panorama with the depth created by the continuation of the image folding out toward the viewer from the background.

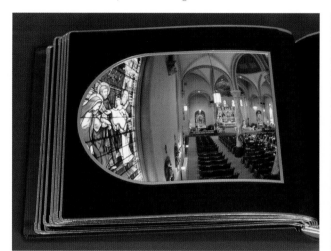

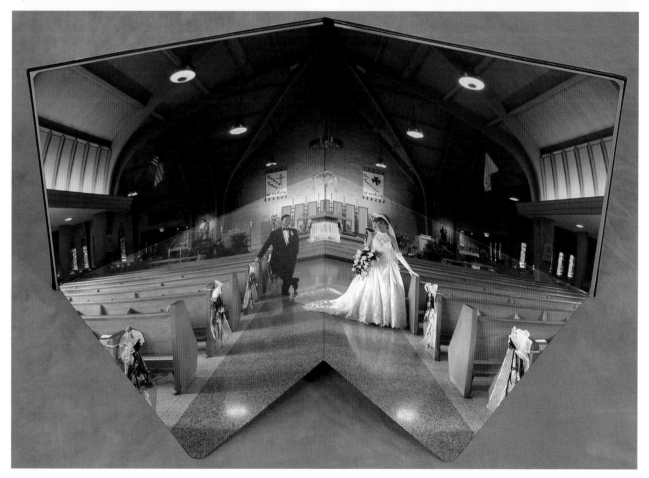

8. Joe Buissink

JOE BUISSINK PHOTOGRAPHY, BEVERLY HILLS, CA

WWW.JOEBUISSINK.COM

In 1993, Joe Buissink was working on a Ph.D. in neuropsychology at UCLA and realized that when he graduated he would be in his mid-to-late fifties, earning a living by sixty, with retirement three or four years later. "I decided to think of something else I could do that I would feel passionate about. Turns out it was photography, but I never considered wedding photography. In my mind's eye I considered wedding photography to be the lowest rung of photography's food chain. But when I shot my first wedding I realized that it's an amazing job. Wedding photographers do this do amazing work. They take a lot of risk and people should give them credit for it.

"I had photography as a hobby," says one of the most in-demand wedding photographers today. "I did landscapes. It's one of the things I used to do in the desert: take a camera, hang out a couple of days, and not think about school. I never sold any prints. It was just for fun. I've never been formally trained as a photographer; I've never taken classes of any sort. Mostly it's been trial and error. It was the same with weddings.

"I had been to two friends' weddings, and came away from both wishing I had had a camera, because the photographers, as diligent as they were about doing formals, spent over two hours and missed the entire wedding that was going on behind them. I would have been shooting the behind-the-scenes stuff. If I were the bride, and twenty years down the line I wanted to look at my photo album, I wouldn't necessarily want to see all of the posed images. Most brides have forgotten everything that went on by the day after. They need the photographs to bring back memories and give them information that is missing about their wedding." Joe's goal is to give them '40s and '50s *Life* magazine style quality.

Buissink is published in *Style, Studio Photography and Design, Vogue* and other magazines on a regular basis. He's been interviewed on television a great deal too. "That's the work of my publicist," explains Joe. "I actually sought it out because once I started speaking and doing workshops all over the country, I realized I had built a name, but only within my peer group. That's not going to

attract a lot of brides outside the referrals I get from photographers. That's how I got this far. But I wanted to expand and have the general public be aware of who I am.

"I called a public relations firm who I'd heard was very good," said Joe. "They had never represented a wedding photographer before but wanted to figure something out. They did a media tour and got me on as many television programs as they could." This area was targeted because Joe already had a presence in magazines. In a matter of two months he was on many different

"Don't get stuck in a comfort zone and let the fear factor keep you from doing something different . . . take risks and trust yourself."

shows. He received e-mails, inquiries, and was hired for a job in Italy over the Internet through *Good Morning, America* because the client saw him on the show.

Joe photographed his first two or three weddings for free in order to build a portfolio. He made 11x14-inch black & white prints mounted to 16x20-inch custom boards, which he used as a portfolio box to show work to get jobs. Those jobs that he gets generate plenty of referrals: "Up to now, and I'm not going to change this, it is all word of mouth," says Joe. "I never advertise."

Joe's first contact with the bride is usually on the phone. "She calls me and tries to find out how much I charge. I try not to discuss specific fees over the phone; instead, I give

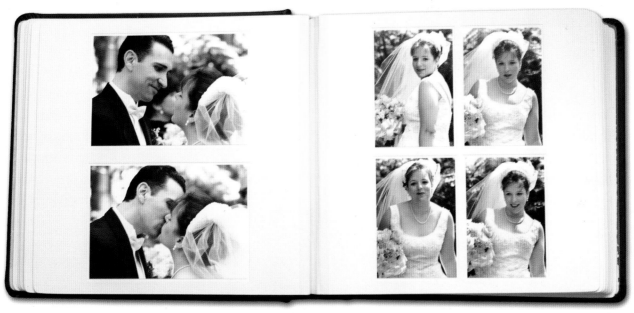

Joe describes himself as a Leather Craftsmen "freak." Note how using different sizes of images in different placements keeps the album from becoming predictable as you turn each page.

her a basic idea of what she will be running into. If my fees do not suit her budget, there is no point in continuing," explains Joe. "However, if it's close enough, I ask her to come in so I can show my work. I meet her to see if we are a good fit. Unbeknownst to brides, I interview them to make sure that I am the right person for the job. If there's not a good personality mix, I'll refer them to another photographer. While sitting across from me, I show them an 11x14-inch portfolio. All the prints are matted and each has a story with it. After going through twenty to forty images, I say 'Now I need you to see a whole wedding, because I don't want you to walk away without realizing that I do this quality of work for the entire wedding.' I might show them two or three sample albums with different styles. All my samples are Leather Craftsmen two-volume sets. I sell two- to three-volume sets all the time. My brides and grooms tend to select about 150 to 200 images.

"I shoot for seven hours," says Joe. "That's seven hours of unobtrusive, nonstop shooting. I would guess that my formal sessions are about fifteen to twenty minutes long at each wedding. And those poses are mostly for Mom." Joe shoots thirty rolls of film on average—about 1,100 images—and he might edit out fifty. Those remaining images are pro-

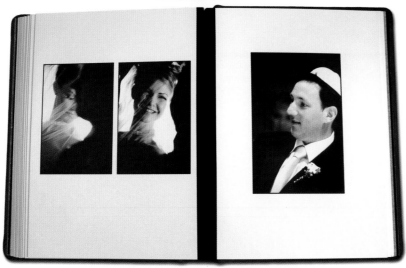

Left—Here a flush-mount book is used with images printed with white borders. Images don't have to be in the center of the page. Printing the image in an unusual position on the page or adding key lines adds interest. Facing Page—A traditional style was used to present nontraditional photographs, mixing sepia tone, black & white, color and spot-color images.

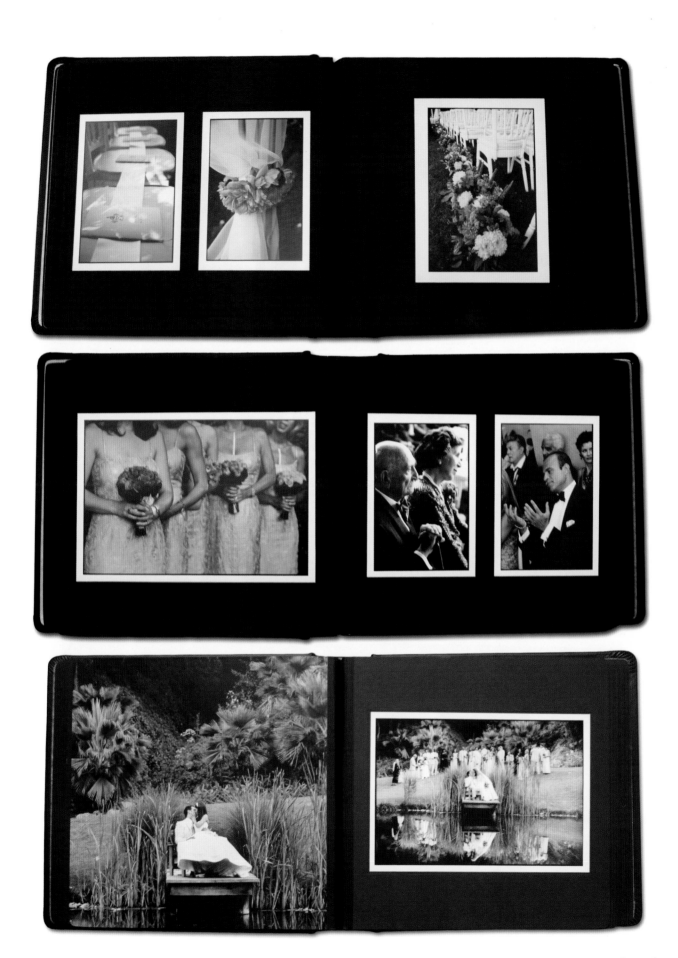

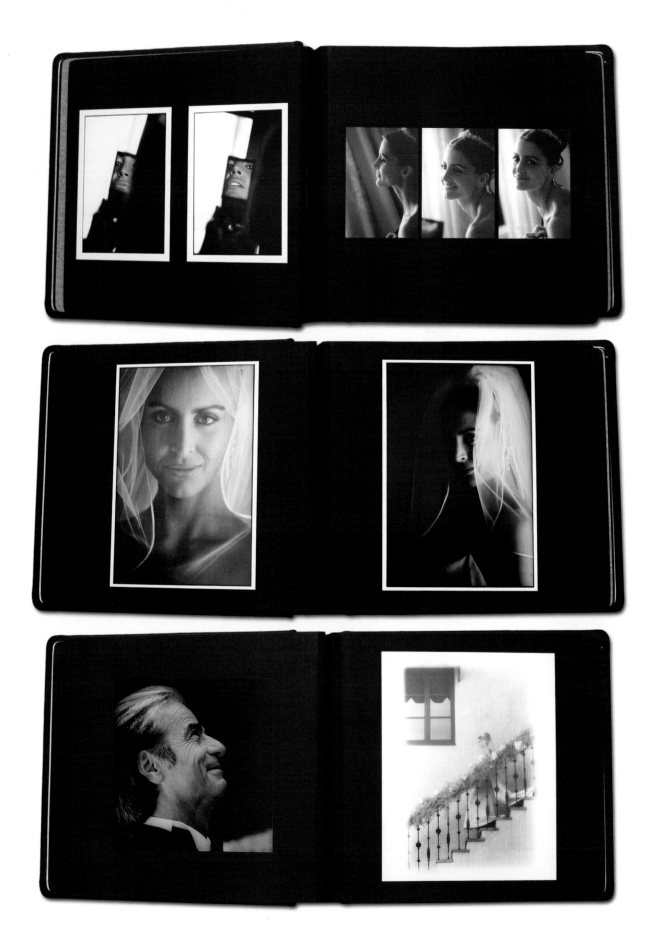

duced as sloppy-border 3x5-inch prints. These are arranged in chronological order and boxed. "I tie ribbon around them, and I might imbed a nice image on the outside cover." Joe tells the couple, "Take them and have fun. I don't care if they get mixed up because the back of the print always has the roll and frame number. They give me all their favorites—and the leftovers—because I know when my printer gets hold of some of my images, he will make outrageous prints."

Joe credits his black & white printer for helping to create and maintain his style. "He develops the film visually using a green safelight. All prints are custom printed on archival paper. When he makes prints, he uses creative dodging and burning, sometimes bending the paper from corner to corner while exposing it under the enlarger. He'll also do creative toning that I would never have thought would work, but turns a good print into a stunning print."

Facing Page—In this album, you can see how Joe combines black & white images in a series to tell the story of the day. Check out the bottom right photo where you can see how the use of split toning that adds a touch of color and makes the image stand out. Below— To maximize their impact, Joe presents his images to future clients one at a time. For this type of presentation, each of the 11x14-inch prints are matted to a size of 16x20-inches, allowing every image to stand on its own.

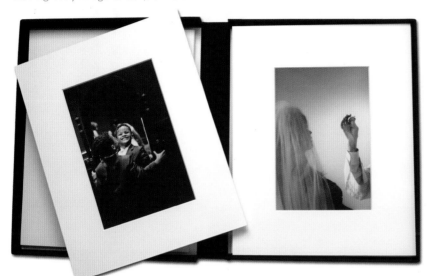

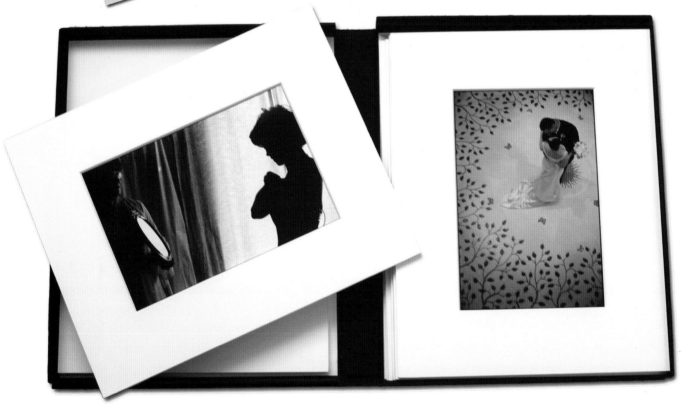

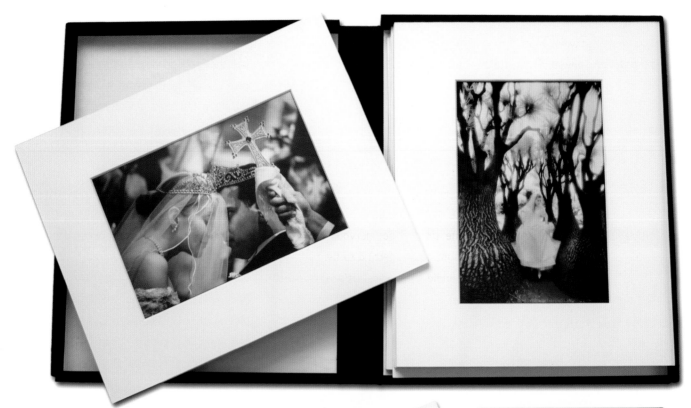

Then it's layout time. "I produce the albums. I'm a Leather Craftsmen freak. When I lay out an album, I start with their favorites and then put in ones that I think are hot," says Joe. "Most of the time they will leave out detail shots that I know are nice little segues or mental pauses." Anything redundant is removed. Prints are laid out upon and pasted onto a sketchpad, which is given to the bride. When approved, Joe makes them sign off on it before printing the final images. "If they change their minds later, it's their nickel," explains Joe. "Once they are all custom printed, the couple come back to me and I show them the final prints. If they want a dress to be a deeper color or have any other requests, I make notes on the back of the prints and I redo the ones

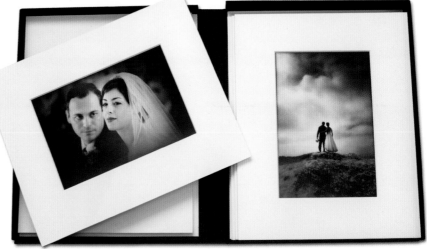

Sepia tone, split tone, and other color enhancements make Buissink's wedding images come to life.

that need tweaking." They sign off on the final prints, then ship them to Leather Craftsmen for binding.

Buissink's prints are all custom-made. He charges couples 100 percent over what he pays to get the images produced. He charges for his services for the day, which can reach

into five figures for seven hours. This includes proof prints. Albums are available at an additional cost, and are also marked up.

Buissink is dipping his toes into digital waters. "Yeah, I'm going to go there. I'm going to try laying out an album digitally and doing these

flush books that I like. But still, the way I present my work doesn't quite come up to the level of a double-weight, fiber-based print done optically by hand by some genius in a darkroom who does this dance around his enlarger. It's not the same. That's how I got here. As long as it's not broken, I'm not going to fix it. I like where I am. I like that it is considered art. I'll wait until I see a little better job on the digital end of it."

Joe advises: "Don't get stuck in a comfort zone and let the fear factor keep you from doing something different. Step out. If it means you do something different in incre-

ments, then do that. Do what you feel is safe and comfortable but then grab a roll of film and just shoot it for yourself. If it happens to come out nicely, you might want to show it to the bride. Play a little bit. Experiment. Go beyond what your comfort level will allow you to do. I play at every wedding. I'm just a little kid in a candy store, playing all the time. I get nervous to this day right before getting to the site; I'm a bundle of nerves. It's a wonderful feeling—I can't wait to get in there and play. Be open-minded, take risks, and trust yourself."

Buissink also suggests net-working and spending time

with other wedding photographers. "I guarantee that if you start refer-ring each other you are going to get more referrals from other photogra-phers than you could ever get from a hotel or a wedding coordinator. It behooves us not to say 'you can't see my work' or backstab or bad-mouth other photographers. When you bad-mouth another photographer, it real-ly speaks ill of you. Connect with each other. Share your work. Know there are differences."

Joe credits his black & white printer with a lot of his success. Creating beautiful images from negatives, Joe's printer performs magic in the darkroom.

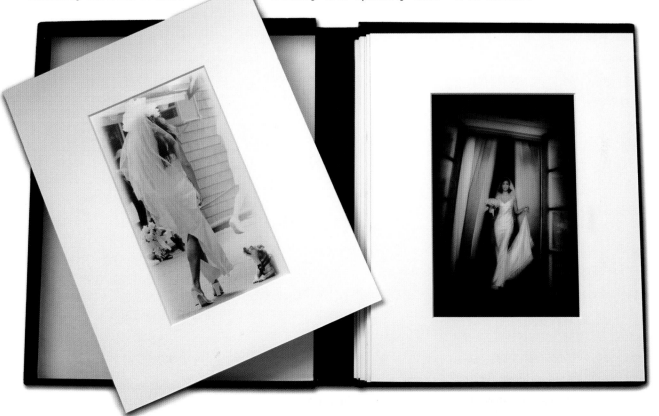

9. Bruce Hudson

HUDSON'S DESIGNER PORTRAITS, RENTON, WA

WWW.BRUCEHUDSON.COM

Bruce Hudson got his start in photography in high school working on yearbook and newspaper photography. Fast forward to his third year of college when he started photographing weddings for friends in the music department. "We were all poor college students in the mid '70s," he explains. "We would photograph the couples and give them the film for fifty to sixty dollars. By the time I graduated I had done twenty-five or thirty weddings. I had a job teaching junior high and high school band and ended up traveling back and forth to different schools each day. I noticed a little photography studio called Pony Photo. Pony Photo mainly did horse shows, but the owner wanted to branch out and do senior portraits and weddings. She started paying seventy-five to eighty dollars to do the weddings. It was all 35mm.

"We became well known in our area, especially through my students. Their older siblings were getting married, and we picked up a lot of weddings that way. In 1981 we were doing 150 weddings per year, netting $150 per wedding at three weddings per weekend. This came out to about $1,800 per month. My monthly teaching salary with a masters degree was about $850. After teaching for three years, one August day I decided that this was going to be my last year of teaching. At about the same time, Phyllis, who owned Pony Photo, offered us the business. My wife Sue quit her job, and we took over the sports contracts and worked out of our home. In 1982 we found a place and opened our own studio."

In addition to holding Master of Photography and Photographic Craftsman degrees from Professional Photographers of America (PPA), Bruce is a member of Camera Craftsmen of America. He's taken the prize for top wedding album in the city every year since 1992, and received three Fuji Masterpiece Awards in 2001. At Wedding and Portrait Photographers International (WPPI), he was the first to win the Album Competition Award in 1993 and the same year won Top Print with a score of 100. He is a highly sought-after speaker at professional photography organizations and has lectured in all fifty states, Canada, Puerto Rico, and New Zealand. Bruce has an extensive line of educational materials, including videos. The how-to technical videos are filmed live while Bruce is photographing weddings or family portraits.

Bruce has always strived to operate a well-rounded studio. Thirty-five percent of his business is weddings, 35 percent seniors, and 30 percent is comprised of family portraits. Seventy-five percent of the brides and grooms Bruce photographs are former high school seniors who graduated five to ten years before. "Marketing for weddings is probably the least of what we do in the stu-

"Look at a lot of different products and choose something that is going to last. After all, you are preserving people's memories."

dio," Hudson explains. "I have a passion for marketing, but the seniors we spoiled are now coming back as brides and grooms. We do a couple of bridal fairs a year and a display in the major hotels and florist shops. We moved up the food chain and looked for the venues and vendors that are at the same level that we are in respect to price."

Explaining his pricing philosophy, Bruce says, "Over the years we have come up with an à la carte system. We offer five different coverage levels: three-, five-, seven-, nine-hour, and unlimited coverage. Depending on the couples' needs, we try to tailor one of those options to fit. Rarely do we do a three-hour session, maybe one every couple years." Hudson Photography designates a portion of their charges as a reservation fee, which is nonrefundable. The remaining 60 to 70 percent of the amount is

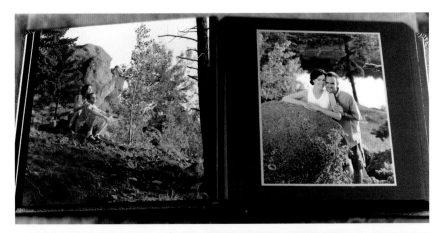

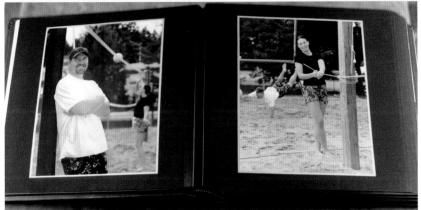

Using Capri albums, Bruce starts off some of his wedding albums with images from the engagement session.

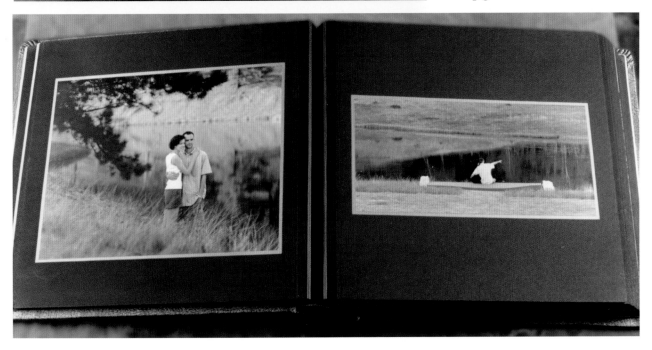

paid in full a month before the event and is called a design credit. This credit is applied toward the purchase of albums, prints, or whatever the couple wishes to purchase. This usually covers 60 to 80 percent of the couples' final tally.

When the couple arrives for a consultation, Bruce shows them his "killer slide show," featuring images from many weddings that are set to music. Following the fifteen- to twenty-minute slide show, Bruce tells the couple about different options and starts the interview process. Questions covered include where the wedding and reception are going to be held, how many people will be in attendance, the size of the wedding party, and the tentative schedule for

Half-panorama pages complement the photos on the opposite page of the album.

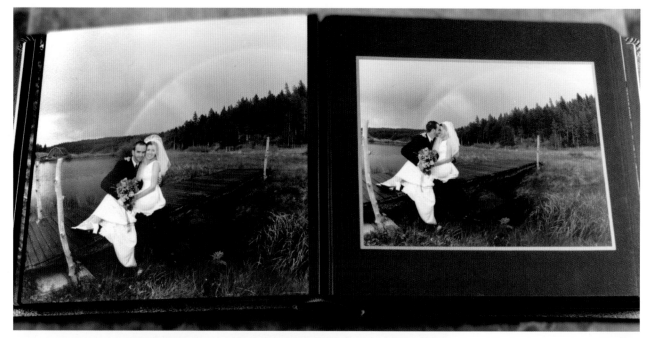

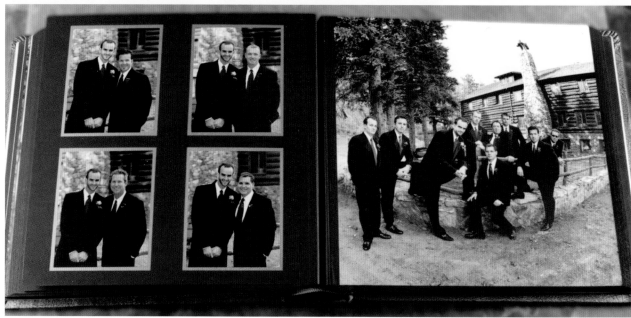

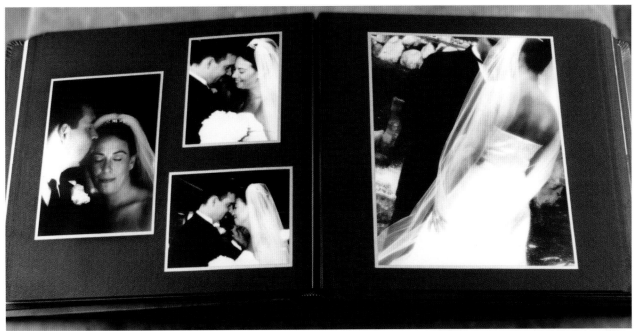

Above—Black & white images with a silver border make the photographs jump off the page. Right—A vertical panoramic image in a horizontal book adds a unique touch.

the day. "After getting as much information as possible, I'm able to recommend a level of coverage," says Bruce. "Then I let them know what amount of time I will need before the ceremony to create the kind of images they saw in the slide show." Hudson then asks for specifics about the reception, helping the clients to visualize the amount of time involved there. "That way, when I recommend a seven-hour coverage they understand. If they aren't blown away by the price I might suggest nine hours and going to a second location before going to the church. I'm lucky that in Seattle the bride and groom seeing each other before the ceremony is not a big issue. I let them know that if they can't give me the time to produce the kind of images they saw in the slide show, then maybe I'm not the right photographer for them."

Hudson believes variety is the key to bigger album sales. He accomplishes this through isolating the subject, capitalizing on artistic and architectural features, using different types of film, and capturing different types of feelings and emotions. Out of ten lenses it's his goal to use at least seven. "Based on the style they want I would say that over 50 percent of my books are photos of the bride and groom. Out of what I take they usually buy 90 percent because it is so different." The number of images depends on the coverage. Says Bruce, "Typically, in a five-hour coverage, they will view 160 images. I'm very efficient with my shooting and I do a very tight edit."

Bruce wanted to find a way to show his images to everyone at once instead of having the proof book out all over the place. He now uses what

he calls a "premiere showing." Bruce gets the names and addresses of all the main players in the wedding—including parents, brothers and sisters, or good friends—for a total of eight to fourteen people, and

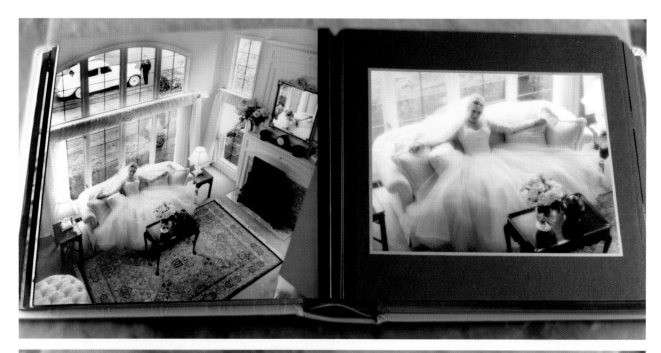

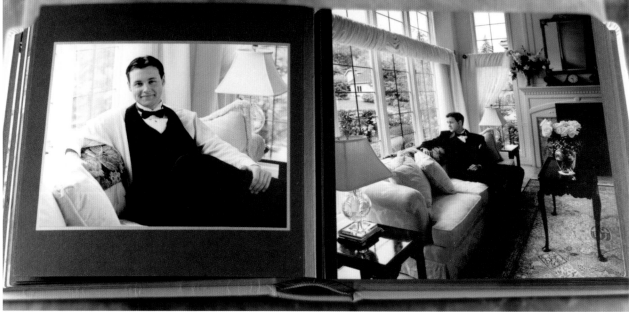

gets them to join the couple at the studio. "We send them personal invitations to the viewing. Using slides or Pro Shots makes it easier on the photographer to maximize sales. Basically you have to be organized enough to get those names and addresses in the file during the final consultation about a month before the wedding. When we send out the invitations, we include a wallet-size image from the wedding.

"I have the premiere showing catered with beverages and hors d'oeuvres, and then proceed to show the images set to music in a slide show." According to Bruce, "This happens three to four weeks after the wedding, and the emotions are overwhelming. I don't want to do it right

Scene-setting pages highlight the beautiful environment and feature close-up photos of the bride and groom within the scene.

Panoramic photos are great for group images and interesting shots. The line down the middle is from the photo being split and butted back together. This avoids the emulsion breaking away from the image as the book is opened and closed.

away. I want the dust to settle and for them to get back into their lives so that when they see it again, it rekindles all that joy and excitement. Then I go through a little five-minute 'here's how to order' speech. After this, we proceed to design the bride's and groom's album and give everybody else in the room an opportunity to purchase photographs that night. The first time we did this, it tripled our sales average. Through the years we have it down to where we have everybody pretty much taken care of in two to two-and-a-half hours." In that time, the album and the parent albums are designed. Parent albums, which contain eighteen to eighty

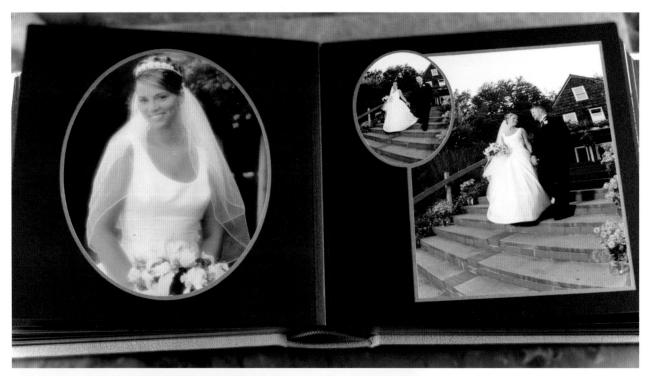

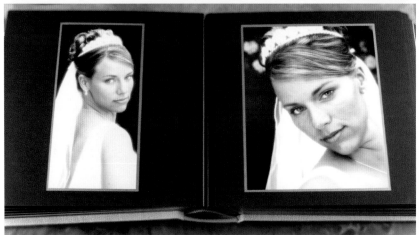

images, generate a nice profit for Bruce. Their popularity is also soaring: Bruce's studio went from one parent album sale every nine or ten weddings to the current 1.8 parent albums per wedding sales average.

Bruce controls the sale by making the choice of photos obvious: he shows the best image first, then presents the third-best image—the clients never see image number two. He directs the design of the album

from the beginning through editing. Albums contain anywhere from eighty images and up. Capri is his album company of choice.

Bruce is currently working on a system to offer online ordering, but plans to provide the option only after all other sales are completed. Not every image will be available online—just a select few images that he thinks people from the wedding might want. These images will only

be available for online viewing and ordering for a short time.

Bruce begins to conceptualize an album design for each bride at their very first meeting, during which he shows a variety of finished wedding albums. He displays eight or ten albums that are either duplicates of what a former bride and groom did, or maybe a distilled version of a two-volume set. In the two-volume sets, he uses panoramas and various-

size prints to promote a theme. The couple is educated right from the start to let the image dictate the final image size that will be printed.

What advice does Bruce have for making greater album sales? Show your work in a very spectacular way. "I show my work via slide projection right now, but next year it may be shown digitally. The key is that the day your client sees the images is the day they buy. That's the day they also

It can't be stressed enough to use different size photos and different layouts to add interest to your albums.

design their album. You don't want any downtime between the two. They know from the initial consultation the way it is going to be done. Also, the finished product should represent their perceived value of it. I person-

ally like bound albums because I think it raises the perceived value. Look at a lot of different products and choose something that is going to last. After all, you are preserving peoples' memories."

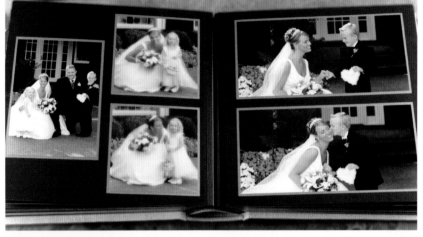

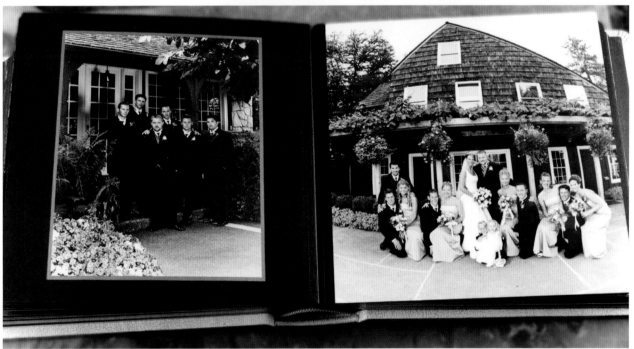

10. Gigi Clark

RITUALS BY DESIGN, OCEANSIDE, CA
WWW.RITUALSPHOTO.COM

Gigi Clark has been interested in photography since she was a little girl. "My grandmother provided me with camera equipment since she was the family photographer, and I acquired technique from her," says Gigi. "Since 90 percent of my hearing is lip reading I am always studying people's faces, so photography comes naturally to me. It's like breathing, very much a part of my life."

Clark is an energetic, in-demand speaker who presents seminars on subjects as varied as motivation, wedding photography, underwater art photography, multimedia presentations, and Photoshop. Her prints have won many awards and her work has been featured in numerous national magazines.

Gigi's finished product for the bride isn't an album—it's a one-of-a-kind photo box. According to Clark, "Ten years ago this was way ahead of the album companies. All pictures are individually mounted in a protective sleeve. In addition, the box has compartments to store keepsakes from the wedding." The exterior of each box is custom finished on the outside to the bride's taste, so no two are alike. Each one is a work of art and is 100 percent archival. In order to maintain clients after the wedding, Gigi offers to do a similar project for the couple's children. "A lot of my brides are now becoming pregnant and having children, and they come back to me. The idea is to have the box grow up with the child and the keepsakes and photographs are stored in an archival manner." This is part of her continuing marketing plan.

How does Clark find her brides? "My grandmother taught me that the best kind of advertising is free, so I network quite a bit. I'm in the Chamber of Commerce and on a committee. This puts me in touch with businesspeople," she said. "When I show my work, it's so unique, people start talking about it. I also do the bridal fairs quite a bit. I've found they are reliable for me. I designed materials to hand out that will attract the groom. Now I get grooms involved—it's about 75 percent brides, 25 percent grooms that call me." While at the fair Clark takes notes about people's reactions to her work to remind her about what they like and who they are. Once the couple is interested, Gigi sells her personality. "We chat on the phone and I try to find out a little something about them. You could call it prescreening, but in a funny, friendly sort of way."

Clark has found the most rewarding advertising has been one-on-one with the client. "I set up a date and let them know I don't like the salesman's approach. I try to be perceived as a fun person to be with before we get anywhere near wedding talk. I arrange to meet at Starbucks, keep-

"Instinct works hand-in-hand with research, allowing us to illustrate our creativity and uniqueness as photographers."

ing it casual and informal. That puts them at ease. How stressed can you get over a good cup of coffee?" At this meeting Clark gives her clients a goody bag to say "thanks for spending time with me.""They get things to hang on to—tactile things to open up," says Gigi—including an accordion-style portfolio of her award-winning images. "In the bag they will also find a beautiful day planner and a wedding countdown list. My logo is on the spine, but it is very low key. They know it came from me, but it's not in-your-face advertising," says Gigi. In addition, Gigi includes a sample custom thank-you card she designed, and current handouts. She also adds a three-inch business card–sized CD. "They take this home and end up doing marketing for me, especially when it comes to Mom and Dad. This allows them to see the same show I presented to them at the coffee house, but without the music." Also in the bag are forms she needs to get information. "I don't pull them out of the bag. I let them do that. I let them drive the whole interview. This way they feel they are in control and are very comfortable about what they are doing.

"Now I've warmed them up," Gigi enthuses. "It's time for a dynamic slide show presentation with great music on my laptop. After that I bring out a couple of my sample boxes with prints for them to go through. From there the interview takes off and assumes a life of its own. It ends when they decide to end

Gigi builds her own boxes, covering them with material chosen by the bride. Photos are mounted and matted with archival material and slipped into plastic sleeves.

it. We meet for almost two hours—they get so engrossed in the whole process they are willing to spend the time. I don't put any sales pressure on them. I just let them enjoy the experience of having a nice cup of coffee with a friend-to-be and then go away. Literally go away. I have no idea whether or not I have closed the

sale, but 90 percent of my meetings like this close."

Clark, known for her distinctive black & white imagery, shoots 90 percent of her images in black & white with a little color thrown in for balance. "Some of my couples want all black & white, and I respect their wishes. Lots of people love black &

Gigi shows how an image may be treated to create two totally different looks.

white, but they don't know why. Black & white flattens the basic components to basic compositional elements. The eye sees the composition—either it works or it doesn't. Color dazzles, black & white clarifies. And, of course, don't forget the timeless quality."

How does Gigi sell her services? "I have traditional packages and nontraditional ones. Discriminating clients like flexibility so I give them that. I have a 'package' that I call an option sheet; it works very much like an à la carte system—what my

clients want is what they get. The brides that hired me last year preferred to build their own albums. They were very decisive about it and anxious to get started. I've learned from them. My style is incredibly simple but clean. The more sophisticated my client is the less fuss and muss they want. Black & white does not like froufrou." Traditional wedding album companies used by Clark are Renaissance and Queensbury.

Gigi's favorite product is her signature image box. The box is covered in the bride's choice of fabric. She

also picks out the shape she wants; diamond is the most popular shape since it has the neatest compartments, but boxes can also be octagon, round, or pyramid shaped. Gigi has even had a box that was a Chinese chest. "The mat board that goes into my boxes is 100 percent rag four-ply mat board cover, two-ply to the back, and in a protective clear archival acetate sleeve," explains Gigi. "I sign every single print, treating each one like an individual work of art. My clients can take each image out of the box and frame them. I've built a new style called the Bride's Showcase, which contains 11x14-inch matted images. I shoot many great images of my couples, so they have a hard time choosing. I always try to give them more than they paid for."

About 1,200 images are captured on the wedding day, depending upon

Sequences tell more of a story than any single image.

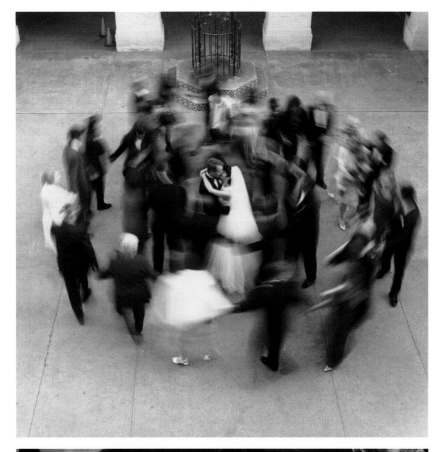

the length of time contracted for by the couple. These images are proofed through Pictage, which is used to scan the negatives and upload them to the web for proofing. Pictage also provides Clark with a proof book, twelve images to an 8^1/$_2$x11-inch sheet, if the bride and groom need a hard copy. "The process is great. They never have to lug around a heavy proof album. You will never see me deliver another proof album. Our sales have increased because of it. I don't have to go chasing my brides down, they don't have to come chasing after me. In addition, I was getting tired of couples scanning proofs and hanging on to proof albums for months, not getting around to getting the album done."

When asked what advice she has for photographers, Gigi says, "Two words come to mind: research, research, and instinct. I realize it's actually three words. I find it imperative to research all kinds of materials. The mind is very resilient in the acquisition of 'over-information,' allowing us to fill up our mental Rolodexes. The result is a continuous flow of inspiration that presents itself in situations that demand 'instant' creativity. Many times, we photographers feel rather empty-handed when a client wants some spontaneous creativity for their session. By law, by right, they should expect us to deliver. Fortunately for

us artistic individ-
uals, resources abound and we must
motivate ourselves to go after them.

"Instinct, on the other hand, is
your vision enhanced to the point of
becoming 'all seeing.' The powers of
observation cannot be questioned;
observation is but a tool in that
moment of decision, that crucial time
that we trip the shutter. Learning
to utilize it results in a 'wow' image.
Instinct works hand-in-hand with
research, allowing us to illustrate
our creativity and uniqueness as
photographers."

*Detail photos of getting ready, or still-life
setups of the bride's dress and accessories
capture memories that will last.*

11. Martin Schembri

Martin Schembri got his start in photography by accident. He originally studied surveying, but hated it—in his opinion there were too many snakes around, and the work was generally very boring. Photography was a hobby for Martin, and when the opportunity came to apply for a job in baby photography, he got down on his knees and begged for the chance. "I guess the studio felt sorry for me and gave me the job."

It soon became apparent that photography would become Martin's career. "Frankly, I couldn't see myself doing anything but holding a camera in my hand. The more I learned, the more exciting the profession became." The "baby photography stint," as he calls it, taught Martin much about patience and speed. A well-established Sydney photographer approached him to join in a partnership. The offer—photographing schools—was too good to refuse, and he worked with him for about four years. After much consideration, Schembri decided that it was time to move on and establish his own studio. He continued photographing schools under his own

name, but became bored with the routine. He began accepting more requests to do portraits and weddings. "The funny thing is that after twenty-five years, the excitement is still there today," exclaims Martin.

Schembri is a highly-awarded photographer who holds a Double Master of Photography degree with the Australian Institute of Professional Photographers (AIPP) (he has been a full member of the organization since 1985). Other awards include the New South Wales (his home state) Wedding Photographer of the Year and a bag full of Gold and Silver Awards from entering state and national competitions sponsored by the AIPP. Martin has also conducted national and international workshops and been featured in numerous magazine articles.

Schembri markets his photography services through wedding magazines and the occasional bridal fair. However, he finds that about 70 percent of his work comes through referrals, which are generated by good service, quality work, and a very strong relationship with clients. He has tried different ways to generate

more referrals, such as free prints and discounts, but found most clients referred him without any incentives and have continued a long relationship with the studio.

How does Martin handle the first contact with the bride? "We generally welcome the call with a positive and cheerful attitude. After establishing the type of photography they require, we explain we have a strict policy of only photographing one wedding per day and assure them that I will personally photograph their wedding. How far in advance the wedding inquiry is made gives us

"Most photographers also run small studies and face the same problems you face. Sharing your frustrations will give you more inspiration to continue."

c r aig & rachael
9th. january 1999

photographed & produced by martin schembri

*Martin uses Albums Australia for his print-
ing and binding. Turnaround time is four to
six weeks.*

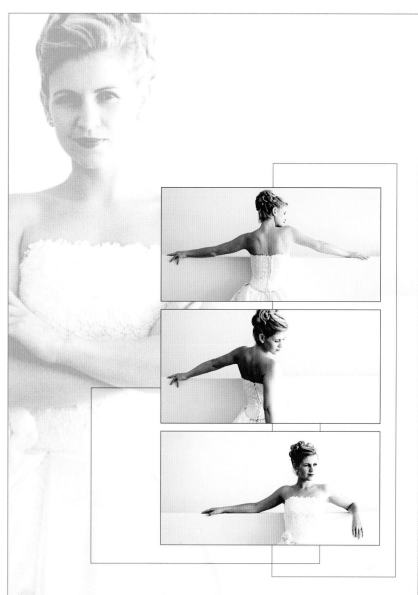

a good indication of the client's out-
look toward their wedding photogra-
phy. With light conversation, we dis-
creetly screen the client by simply
asking questions." Martin's ques-
tions include: how the client obtained
his phone number, have they visited
the web site, where the church and
reception will be, and the amount of
coverage they require. "Adding to
this," says Martin, "we continue ask-
ing small things about their honey-
moon, guest numbers, bridesmaids,
etc. This gives us a fair assumption of
the clients' wants and needs and we
offer a rough estimate of our prices.
Establishing that our prices are with-
in their budget, a studio appointment
is arranged."

Engagement portraits are encour-
aged in Schembri's coverage and are

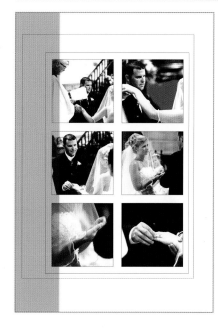

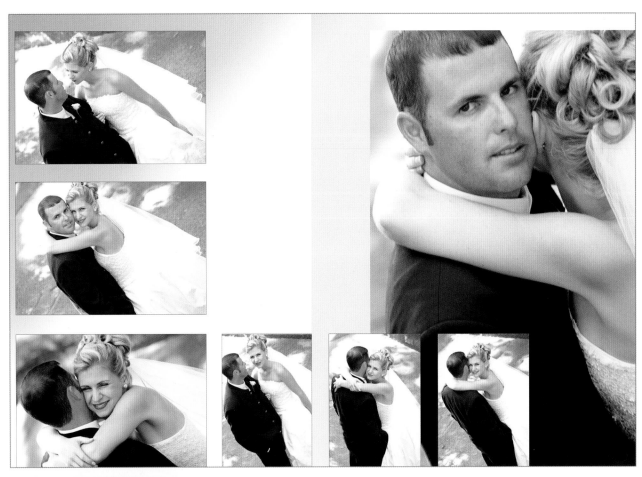

Schembri uses page layout software he designed and has made available for sale to other photographers. The templates help give a cohesive look to the design and can be a great time saver.

usually included in their wedding packages at no extra charge. "However, the sitting is free, not the prints. Our average sale for these sittings is about $600 to $750 US. The trick is to ensure that the sitting is conducted about a month after they have booked the wedding date." Martin sells the couple on displaying prints from the engagement session at the reception, noting that his collage layouts are extremely popular.

Most of Martin's wedding coverage includes attending the groom's and bride's homes approximately one hour before they are due to leave for the services. Depending on the time the service is booked, he usually

takes two to three hours to do location and formal photography after the ceremony. This is followed by reception coverage, which normally ends around midnight. If the bride and groom choose full reception coverage they might also choose an add-on called "night shots." These are photographed under Harbor Bridge, including city and opera house backgrounds. If the weather is bad, these photos are made inside their hotel foyer and bedrooms. Another option for clients on a budget is Martin attending the first part of the reception to only photograph a mock-up of the cake-cutting, toast, or other events. This normally takes about thirty minutes.

Images from the same time and place are arranged in different size and shapes.

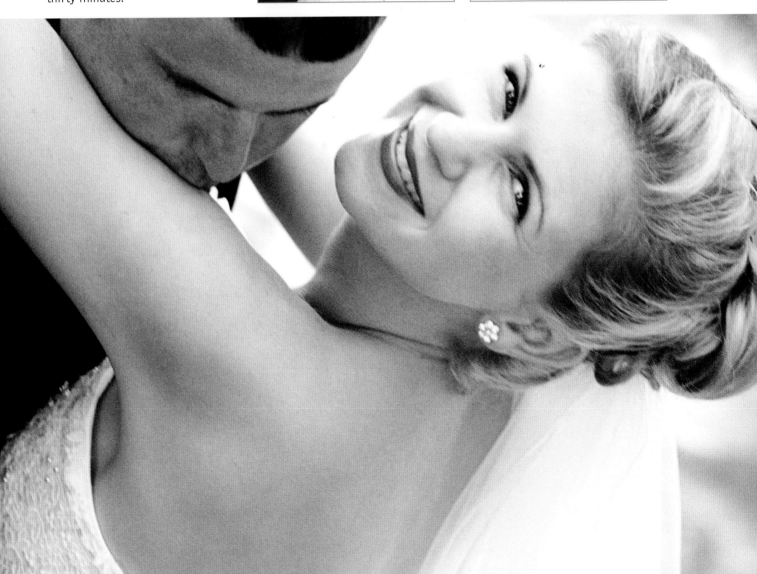

With fully-digital shooting, Martin Schembri Photography produces DVD proofs. They use a variety of programs to make them: ACDSee to sort, edit, and rename; Foto Page Platinum to resize the originals; and iDVD2 to burn the DVDs from his G4 Macintosh. The DVD is presented to the client in a personalized case with a photo, name, and date. Clients receive their proof package after the album planning session.

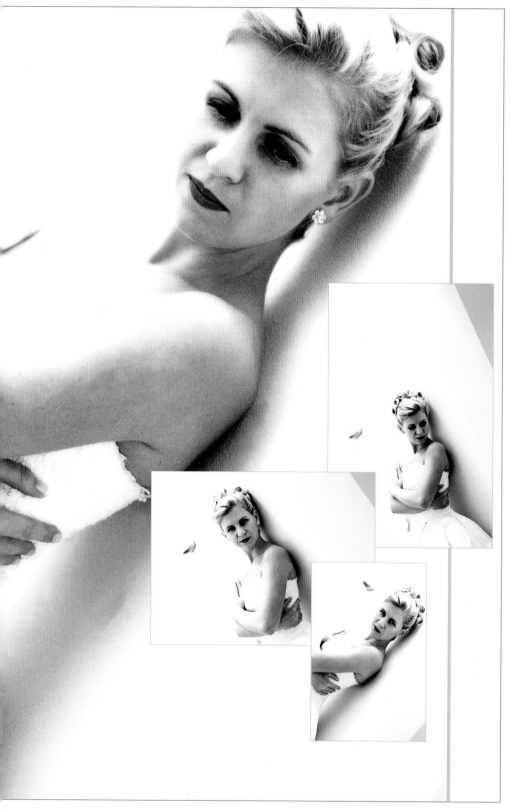

Martin's page layouts include different image sizes, ghosted images, key lines, and drop shadows.

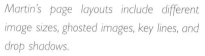

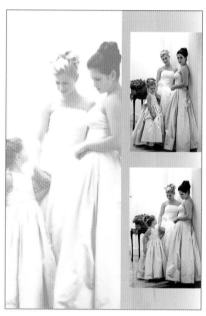

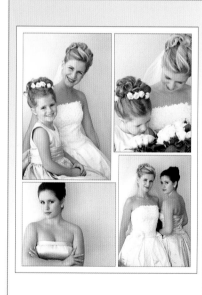

Schembri uses an album planning program supplied by Albums Australia, Inc., which shows an album layout with the images designed within each mat. "I normally allow approximately three to four hours for an album planning session," Martin explains. "Before the client comes in, I preselect the best images and design their album as a total story sequence from beginning to end. The program also allows us to apply music files and show the proposed layout as a slide show. After tears are wiped away, we show the entire collection of all the images and invite them to change or delete any pages or images they wish. If they agree not to delete any of the pages I have designed, I offer incentives like free embossing or a carrying case." Martin firmly believes that this is more appreciated than a discount, yet helps the client to accept the extra charges beyond the original package.

Schembri's pricing philosophy is based on the premise that the value of the image is not based on the size of the print, but the time and infrastructure that produced the image. "I price my work accordingly and refuse to compromise my prices just to win over a job on the basis of price alone. My clients pay a minimum price per print, whether the image is the size of a postage stamp or an 8x10." His work is priced to include full retouching, custom printing, and outstanding presentation. "I use Albums Australia, Inc.. Depending

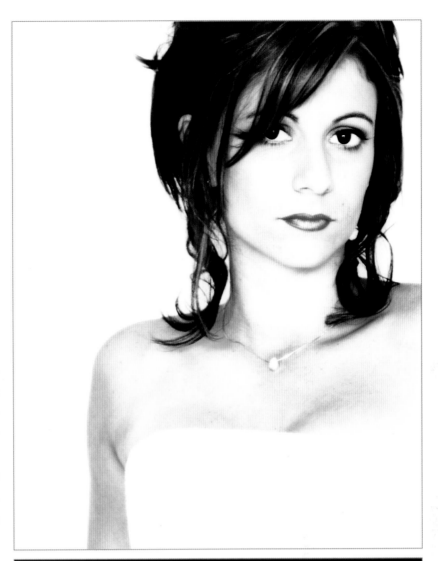

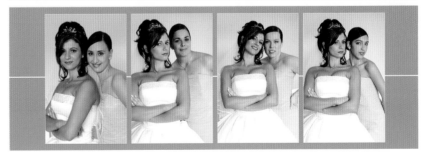

Top and Center—Martin took three high key images and blended them into one panel. Bottom—A series of images can capture the relationship between two people.

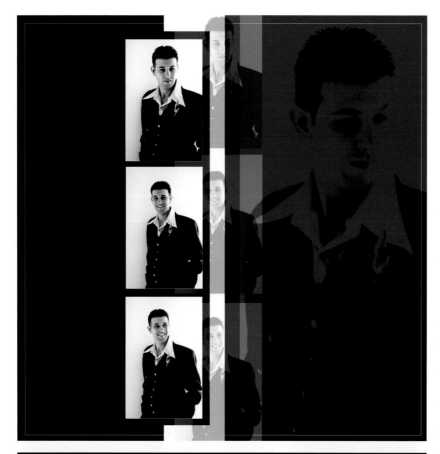

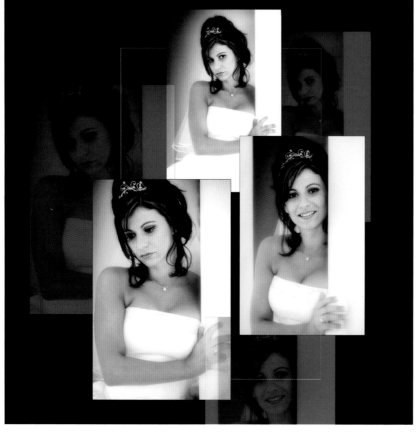

on the size and type of album, the normal turnaround time averages four to six weeks."

Schembri also offers his clients a magazine-style album that includes fully-mounted pages with digitally designed collages on every page. Other available design features are digital design collages mixed into a traditional-style album, single or double-page panoramic enlargements fully mounted onto the album pages, and a double-spread reception collage of about thirty images. These features are available in parent albums also.

The studio also offers an interesting add-on: a parent gift enlargement that is photographed during the afternoon of the wedding, then printed and framed within a couple of hours. Prearranged with a local lab, these are finished and presented to the parents at the reception. This usually adds an extra $600 US to the package price.

Martin's predesigned digital template program is also available for purchase by other photographers. It contains over 140 individual designs of collage layouts, which have proved to be extremely popular.

Schembri offers these words of wisdom: "Think long and hard about the hours, weekend work, and risks

Darkening and toning images, then presenting them with the regular image, is another possible design element.

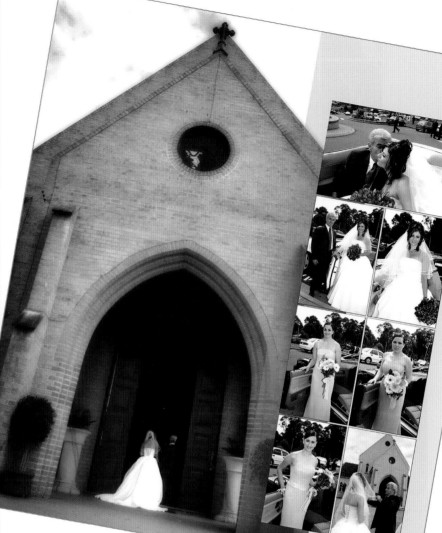

Graphic design elements
highlight Martin's albums. Split black & white back-
grounds, key lines, ghosted images, and more are available in his software.

involved in shooting an event that cannot be repeated. Know your gear well and make sure it works. Carry backup gear. Have a good insurance policy. Crawl first, listen to your peers, and then walk slowly. Set your goals and keep on track. Introduce a shooting policy that suits you and your photography. Be prepared for many disappointments, but don't let these distract your vision. The rewards are there if you work hard enough for them.

"Persistence, patience, and desire to succeed are my creed. If you are not hungry enough, you won't achieve your dreams. Don't give up. Set a goal for what you want from your career in five years. It really doesn't matter what your goal is; it could be a trip around the world, a new car, whatever. Just set the goal and use it

12. Charles and Jennifer Maring

MARING PHOTOGRAPHY, INC., WALLINGFORD, CT
WWW.MARINGPHOTO.COM

Chuck and Jennifer Maring both had their first view of photography at a young age and started their careers from the printing side. "My first experience with photography and Photoshop was kind of all at once," Chuck explains. "My brother, who is ten years older, was doing some fashion photography. Dad built him a darkroom, but my brother lost interest. Dad printed fine art work as a hobby and loved the printing side, and I developed pictures with him. I always paid attention." Chuck was exposed to wedding photography when his parents started photographing weddings on a freelance basis. His parents did their own printing, both color and black & white, and Chuck began assisting them. Later, Chuck went to work outside the family business for a photo lab and photographer for a period of five years.

"We lived very close to New York City," says Jennifer. "I was constantly in a city atmosphere, being exposed to visual art. My parents enjoyed photography as well, so photography was always around me." Starting in high school, Jennifer worked in a lab with a photographer, which added to her understanding of the technical side of photography. It turns out that this was the same lab Chuck had worked in five years before.

Neither of these photographers is a stranger to awards. Their combined achievements include six Connecticut Photographer of the Year Awards, three Kodak Gallery Awards, two Fuji Masterpieces in the past two years, and the Grand Award from Wedding and Portrait Photographers International for their 2000 album. They also present programs at numerous conventions.

Chuck and Jennifer capture 100 percent of their images digitally. "When most brides call, they ask if we shoot in black & white or in color. The way we answer that question is, 'You are going to see digitally mastered photography, not to be confused with just digitally capturing and printing the work.'" Chuck explains to their customers that an actual human being takes pride in the print quality. They believe the person taking the picture supplies the canvas and oils, and the person printing the photograph is the painter. "We are really pushing the idea of not just the

standard print, but a more refined quality where we are burning and dodging on every page of the album. We take pride in the details. We are using our Photoshop knowledge to its full potential."

How do the Marings answer objections to digital imaging? "By using key phrases like 'digitally mastered,'" explains Chuck. "I ask the bride, 'Do you know the difference between DVD and VHS?' I explain that is the difference in clarity you will see in our work." Chuck and Jennifer also explain the difference in the level of creativity their clients will see. They are really pushing the

"When it comes to design,

I don't think that

one album company can

fill every bride's needs."

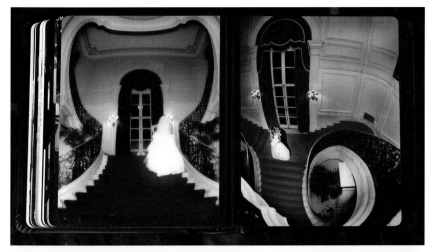

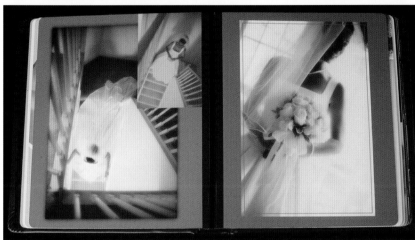

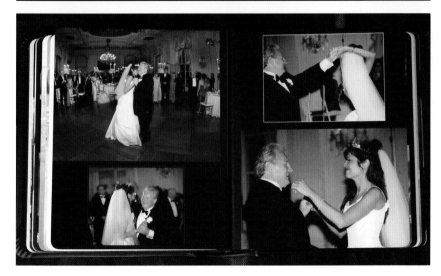

The Marings utilize Photoshop to get the most out of their images and layouts. Photoshop techniques such as selective focus, conversion to sepia or black & white, retouching, and special effects enhance every image. The albums shown above are from Zookbinders album company.

idea that digital is stronger. "When we are talking on the phone to a bride our first question is, 'Have you seen our web site?' This way, they already know that we're very creative, and they look forward to coming into the gallery. The web site is the key to giving clients a good first impression."

At the first meeting the Marings greet their clients, let them walk around the gallery, view images, and make their own determination of quality. "Then we sit down with them," says Chuck. "We listen to our couple. I believe there is a place in the world for photojournalism and portraiture, but everything is based on the clients' tastes. If they say they want photojournalism exclusively, we pull that out. If they are looking for a good blend of photojournalism and portraiture, we show that. We let them make the decision on how much 'nonfiction' photojournalism and what level of portraiture they want." Jennifer continues, "We also have the wow factor. From the moment they step through the door it smells nice and feels nice; it's comfortable, not stuffy. We are dealing with a lot of women, and I want the experience to be very positive. We have been showcasing a lot of multimedia."

Chuck and Jennifer present their images on big-screen televisions that are networked to computers. Using Kai's Power Show or Flash Five presentation, they highlight the style of photography the couple is looking for. Then they go through a few albums.

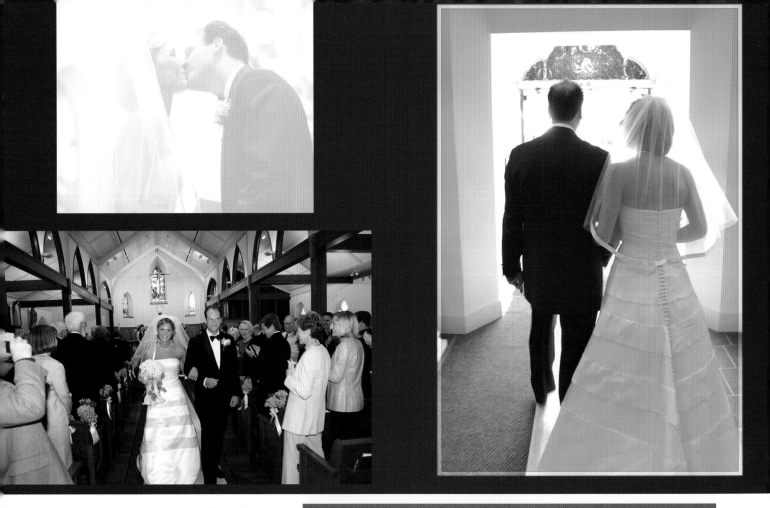

"When it comes to album design, I want to get a feeling for where they are coming from. I don't believe that one album company can fill every bride's needs. Are they looking for something outrageous and different, something traditional, or traditional on the contemporary side?" The Marings use Zookbinder for traditional and contemporary classic collections, DigiCraft for something different, and Art Leather for parent albums and proofing. They also use GNP (Gross National Product). "Most wedding clients buy wall portraits because our work is done in a creative fashion. People don't feel there is just a big photograph of them on the wall, but a piece of art." Chuck credits large print sales to

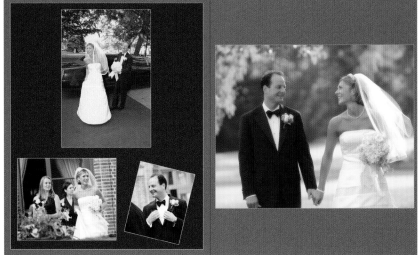

Above and Facing Page—Note the color harmonies that tie the pages together along with the use of black & white and color on the same spreads. Albums bound by Digicraft with images the Marings printed themselves.

selling via the big screen. "We pre-design several images of suggested wall portraits, and we show those images, creating the sale."

"This process is very, very important. We give our couples a virtual wedding brochure," explains Jennifer. "It's a huge thing for us

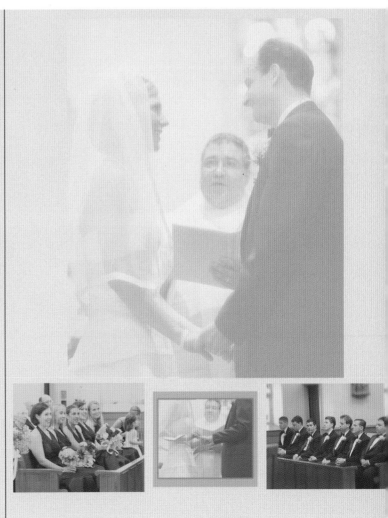

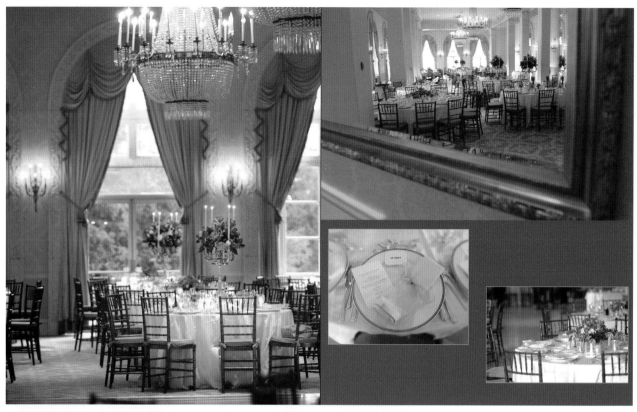

This Page and Facing Page—Warm, rich colors, room details, and photography with an advertising feel highlight the Marings' albums.

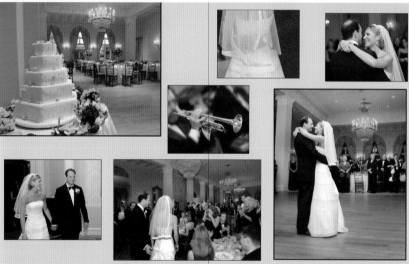

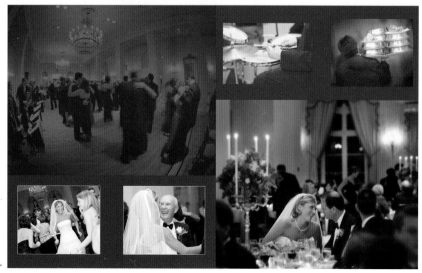

because our work is hard to describe. Beginning the virtual brochure is a multimedia presentation slide show of refined images of one whole wedding story. We want to show consistency, not just sporadic images. Then it's like navigating a web site. We show different collections, album styles, and page layouts so they can see the designer quality we produce. The presentation also includes pricing and credentials. It's built in Flash Five and burned to CD (and soon on DVD) so the whole family can gather around the television and see it.

"We are going to see people who know how to reach the bride in more creative ways in the near future. Look forward. Don't just learn Photoshop. Dive into web site design and multimedia presentations. We found a new product in that. Brides want a multimedia presentation of their own wedding. So we put their wedding album images creatively on a DVD, as a companion piece to their wedding albums."

"Most weddings last between six and fifteen hours. Our album collections (packages) start with a single volume for an eight-hour day with 100 hand-printed and mounted photographs. The next collection shifts to ten hours, which includes a double volume. Twelve plus hours are needed for a triple volume. We want clients to walk out feeling that they got the

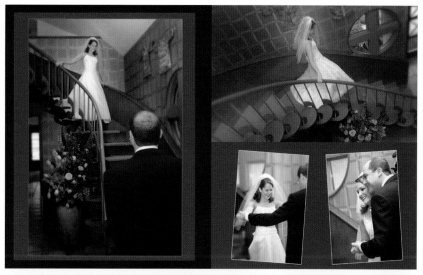

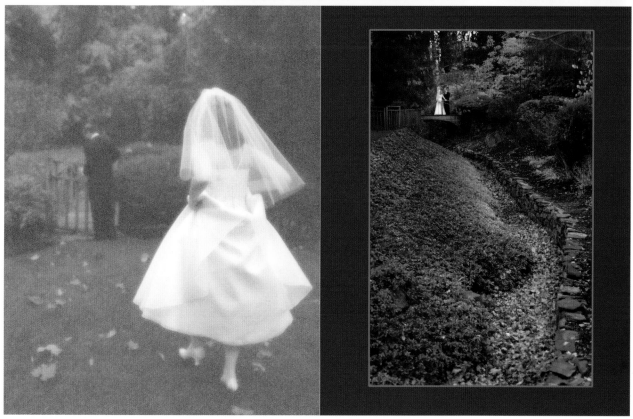

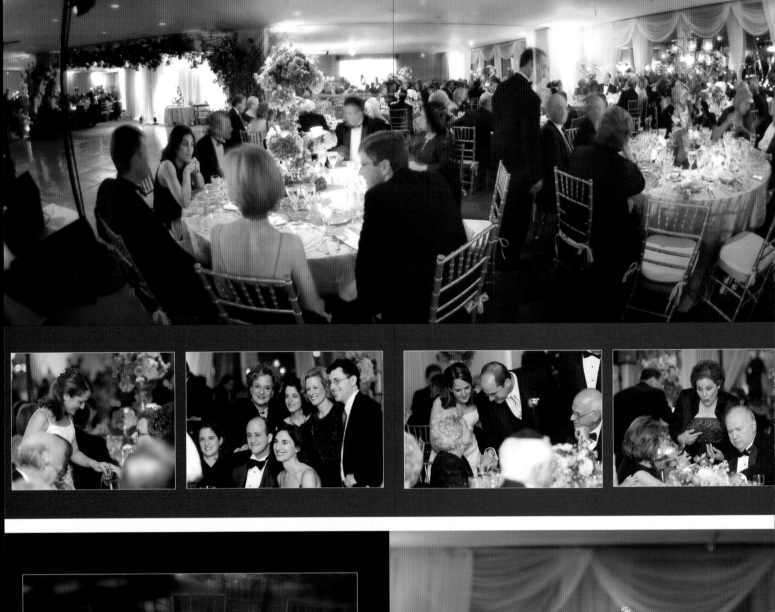

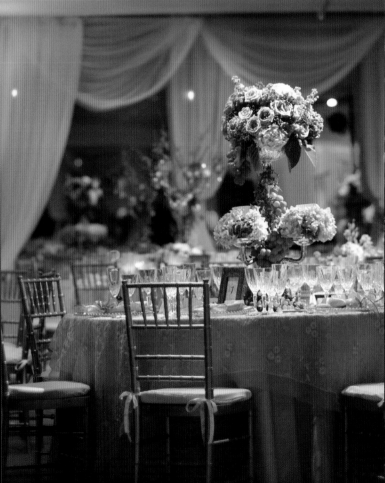

best thing we can create based on their day." Their pricing structure started à la carte, but Chuck wanted to eliminate those few couples who would come in after the wedding day when they realized they didn't have money and couldn't afford to walk away with something that the Marings were proud to hand them.

They now use an up-front pricing structure. "Clients have the ability to choose coverage time and albums. I'm not trying to upsell them an album afterward. Our clients pay a lot of money for other vendors. I want them to have the preconception that my product is on par with everything else that they have purchased,

including beautiful gowns, flowers, and dinner."

Using the Nikon D1X, the Marings shoot with complete freedom. "We go to town and capture between 700 and 2,000 images and typically edit out about 20 percent. We want to give them everything, but don't want to overwhelm them. We are

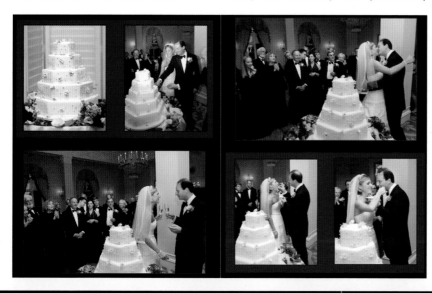

This Page and Facing Page—The combination of digital capture and Photoshop allow the Marings to complete their album designs in a creative fashion.

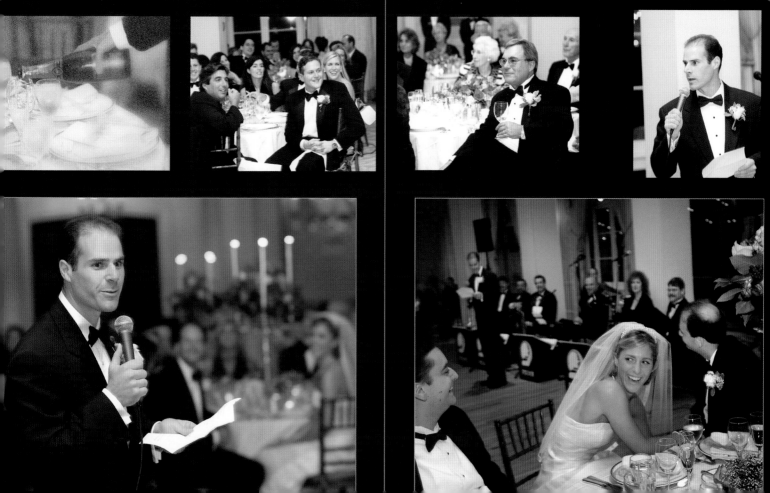

creating contact books with enlarged contact sheets, sixteen images on a 10x13-inch sheet in books from Art Leather. We've been doing this for years. Now other photographers are coming to us to produce these as well. Our lab, resolutionlab.com—a company that my family owns—is providing these services."

The couple's contact books are presented in two to three weeks. The Marings find brides like this system better than proofs. "Who wants to carry around a thousand photographs in a bunch of bulky proof albums or in a box? We don't just print the proofs, we predesign the album," continues Chuck. "We do all the

Above Left—Multivolume albums in slipcases. Above Right—A brilliant splash of red leather with the name and date as the only cover enhancement. Right—DigiCraft brushed aluminum cover.

album design work up front. That may sound crazy, but we've learned if we go over their original album size, they usually add to what we have suggested.

"We shoot completely in color," explains Chuck. "This gives both Mom and the bride the freedom to do what they like. We switch images to black & white, burn, dodge, and refine 150 images. That's how we earn creative freedom. When I come home from a wedding, it's fresh in my

mind. I'm excited about the images I just took. Now is the time to put that creative vision on paper. When we did it the other way and prints came back months later, I wasn't as excited to do that print work. My

clients end up ordering 90 percent of the photographs that I design. When I print their album, 90 percent of my postproduction work is already done. The client knows I do have that option of black & white or sepia tone, and they get to see the artwork firsthand.

"We find couples are giving us complete creative freedom. They look at the color proof images and then at the refined ones, and they realize they don't think like that. They leave it up to me to determine what is in the best interest of each photograph and the story. From the pre-designed images I select fifty to upload to a new wedding section of the web site, to put the best-case scenario out for their family and friends to view. I use the full selection of images to create a multimedia show on the big screen for the parents, and the bride and groom.

"Walk into digital slowly," advises Chuck. "I see a lot of digital work come through the lab that is not up to par. People are diving in rather than stepping in. I suggest going hybrid first and starting slowly so that you are comfortable with it. We don't want couples out there that have a bad taste in their mouths for digital photography. Buy a digital camera today, because your learning curve is going to increase dramatically. Go digital because the quality has come upon us. Seeing the image immediately is invaluable." Jennifer concludes, "Camera systems now are pretty good. They are easy to work with. The Nikon D1X is fabulous. It's not scary. It's not so technical."

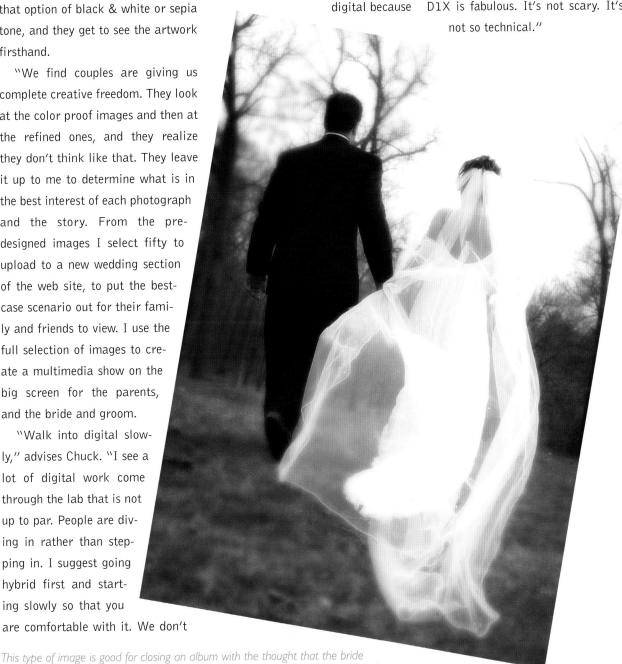

This type of image is good for closing an album with the thought that the bride and groom are heading off into the future.

13. Brian and Judith Shindle

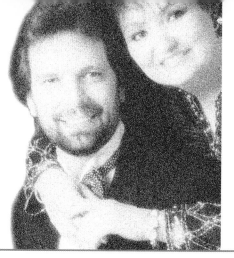

CREATIVE MOMENTS, WESTERVILLE, OH

WWW.SHINDLEWEDDINGS.COM

Brian, the principal photographic artist of the couple, got his start in photography in high school. "A friend of mine and I got cameras and decided to take a photography class. In college, while studying criminal justice (which I was doing because my parents said 'get a real job'), I worked on the school newspaper and yearbook." Brian ended up in charge of those projects before leaving for Ohio State University for a year to study photography and fine art. He went on to work in a camera store and began shooting part time at a studio, eventually working full time at a studio that handled about 3,000 seniors a year.

To Brian, shooting at the high volume studio seemed mechanical, like factory work, and he eventually decided to leave the photography industry altogether. When Judith met Brian he was selling securities. "I was a real estate broker and hired him as a photographer," explains Judith. "He brought in the least amount of equipment and produced incredible images. I knew he was extremely gifted." To make a long story short, they married, became business partners, and opened their own studio in 1986.

Brian is a Master Photographer and Photographic Craftsman through Professional Photographers of America (PPA). He is also a member of the American Society of Photographers (ASP), and one of his Love Safari images (made on-location by client request in New Mexico) was chosen for inclusion in the 2002–3 ASP 100 Print Traveling Loan Exhibit. In addition, Brian is a member of Wedding and Portrait Photographers International (WPPI), through which he has earned two degrees. He has received numerous awards, including the Fuji Masterpiece Award. Brian and Judith's speaking engagements include seminars for PPA, the Winona International School of Professional Photography, regional conventions, and special industry-sponsored events. Judith has earned her Photographic Craftsman degree through PPA, is a member of ASP and WPPI, and is a trustee on the board of the Professional Photographers of Ohio.

"We started the studio with very little equipment, lots of prayer, and with the innate talent that Brian has," says Judith. Now, clients are met with flowers growing outside, and roses are presented to them upon departure. Candles are lit. Appropriate music is played. Ghiradelli chocolates are placed in crystal, while springwater, specialty teas, or Perrier is available. "Silver serving pieces and crystal goblets convey the idea that we value the time our clients have chosen to 'invest' with us.

"We decided to specialize since we could not be all things to all people. We concentrate on creating

"After the wedding, we present a 'media premiere' set to special music. It's a wall-sized presentation."

beautiful photographs that celebrate the family. Instead of photographing 100 weddings a year, we have limited ourselves to photographing one per weekend—and not necessarily every

The Shindles use Leather Craftsmen albums. Here we see a panoramic print (bottom) and a color circle facing three black & white images (top).

weekend!" They have built their services to include not only the wedding, but also all the things leading up to the wedding by creating a wonderful Love Safari, an extended portrait session that covers different looks and locations. "It is one of the reasons people come to us. The Love Safari can be their engagement, someplace they are particularly

drawn to, or a place to which they want to travel. We are there to serve that bride and groom through that period of time and beyond."

Judith is designated as one of only thirty-one master bridal consultants in the world, according to her membership in the international group, the Association of Bridal Consultants. She knows how to pamper

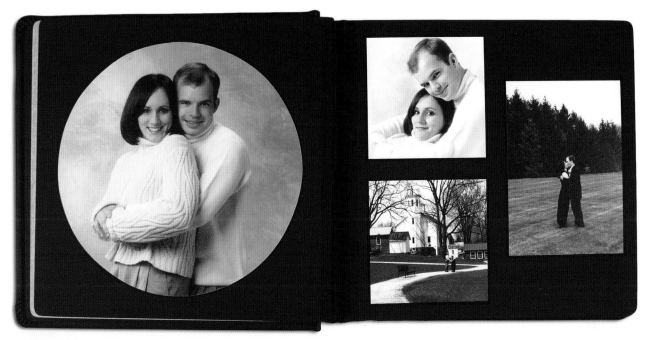

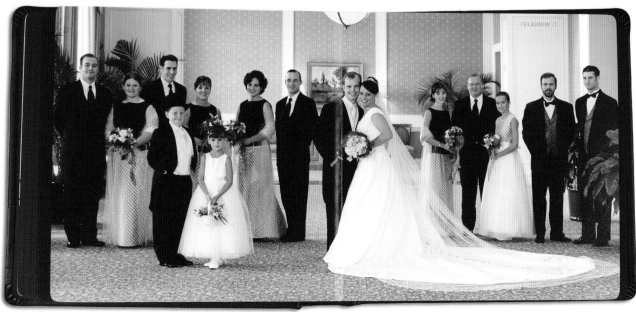

clients; she also provides additional merchandising services—including beautifully crafted wedding invitations (made by calligraphers hired by Brian and Judith)—that go hand-in-hand with Brian's photography. The rationale is this: couples have enough on their plates when it comes to planning a wedding. By meeting one more of the couple's wedding needs, Judith is able to alleviate some of her clients' stress and give the couple the opportunity to enlist the help of a vendor whom they already know and trust.

Marketing is done primarily through small black & white ads in two local bridal magazines, supplemented by national and regional interviews. The Shindles have not done any bridal shows but have attended a couple "by invitation only" events in the last seventeen

Close-up and full-length portraits are all part of a comprehensive wedding album.

years. Most of their work is obtained through personal referrals from their customers and other vendors.

Judith handles all client inquiries because she feels customers form an opinion about the business within

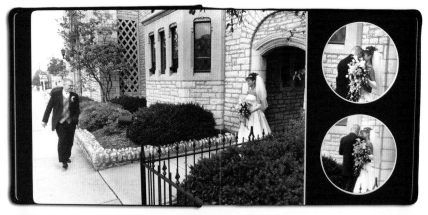

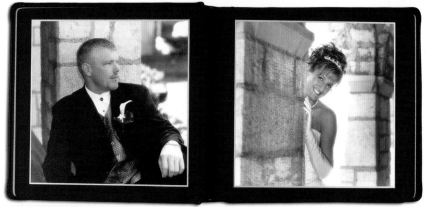

those first minutes of contact. "I have a vested interest and am enthusiastic about what we offer and what we can do for them. If, during that first call, I don't feel that there is going to be a very good 'mix,' I glad-

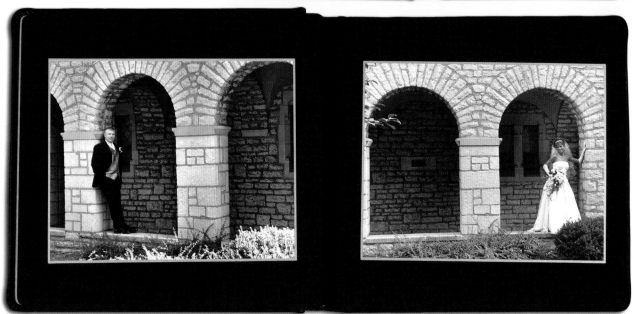

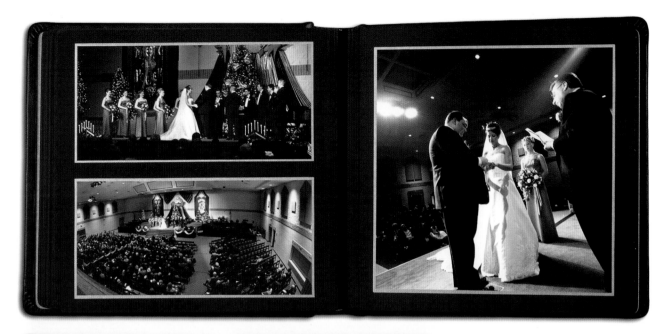

This book shows a silver liner. Many other colors and styles are available.

together and not just their wedding photographer.

"We have an interview process during which we listen carefully to the wants and needs of the couple and provide different options on how they can be photographed. Every wedding is photographed differently. It depends on that bride and groom. Brian and I formulate a plan with our client on where, how, and when the images will be captured with our unobtrusive photographic approach."

Once prospective clients are ready to sign on, they reserve their wedding date and sign a wedding agreement in which event dates and times and personnel assignments are finalized. Judith schedules a time line for capturing not only the wedding day, but also the engagement party, the rehearsal dinner, the bridesmaids' luncheon, the groomsmen's outings,

ly refer them to someone else with whom I feel there may be a better fit. That doesn't mean just the financial portion of it. If I feel that the personalities or expectations will not be compatible, then I suggest a photog-rapher who I believe will be able to do the kind of job they want. It is important to feel that a good rapport is possible between us. Ultimately, our goal is to be the couple's family photographer through their lives

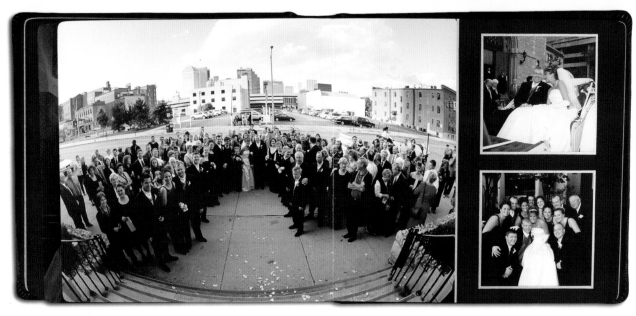

or the couple's shower—special events in the lives of the couple that round out the wedding album with beautiful memories and a storytelling approach that leads to additional album, image box, framing, and print sales for the Shindles. From here, the studio expectations and services, album architecture, pricing, and the payment schedule are discussed. Judith also outlines simple but important issues such as parking, reception meals, newspaper glossies, and optional services such as professional bridal consulting, invitations, calligraphy, packing-sealing-mailing services, accessories, and the rental of a few "custom pieces." Also included with each wedding agreement is a release for images created for use in the Shindles' advertising, display, promotion, and future media projects.

With the wedding day reserved, the couple is officially registered at Creative Moments, and friends and family members can purchase beautiful linen gift certificates—presented in signature gift wrap—that offset the cost of the couple's order and allows them to spend more on their wedding photography. Says Judith, "Couples are informed how the personalized album design process is

going to work in the initial interview, as well as in the agreement they sign. We have many brides and grooms who do more than one album. Additional album orders usually come from members of the family as well."

Creative Moments' pricing philosophy does not include packages; instead, the couple can select the items that best suit their particular

needs and their budget. "An investment menu is presented during the bride and groom's first visit," says Judith. "The clients are given choices in accordance with how much money they have to spend." Creative Moments' minimum investment fee is paid up front. Brian's creation fee is paid when the couple confirms their wedding date. The balance is due ninety days prior to the wedding.

Facing Page—Three-quarter panoramas shown with different end elements. Right—Half- and three-quarter–panoramas, thin prints, and insets show many of the different options.

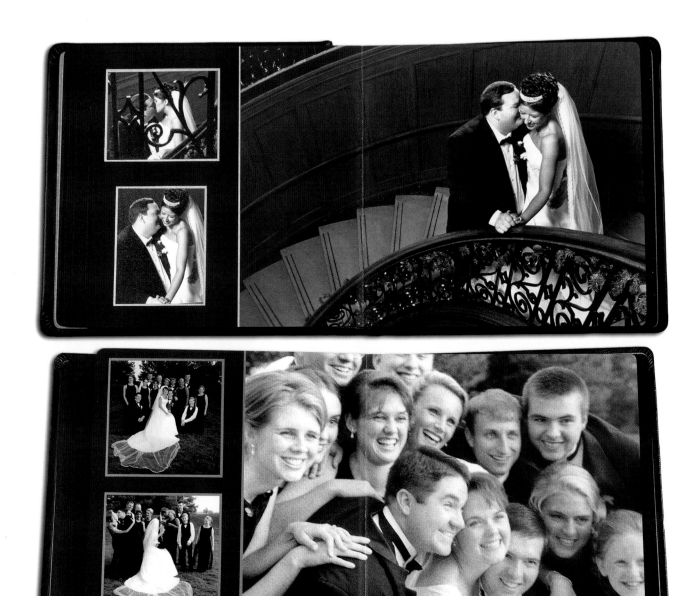

Top—Two 4x5-inch black & white prints begin a theme that is continued with the panoramic staircase image on the facing page of the album. Bottom—Again, two small photos complement the panoramic close-up on the facing page of the album.

Brian's shooting style at the wedding is a "blended" coverage. He finds that brides and grooms like documentary-style and photojournalistic coverage, but also like beautiful portraits and formal group shots.

Weddings are like family reunions, and many clients want to capture that togetherness. Brian also photographs scene-setters to show where the event took place; some montages that showcase the personalities of the bride and groom; a close-up of the wedding dress or veil; the place cards; details of the cake, and any other details that tell the story. Brian captures 200 to 600 images on a wedding day and edits out about 5 to

10 percent depending on the wedding. Although she's not billed as a photographer, Judith keeps a camera with her, set on automatic, and captures special moments as she sees them.

"Post-wedding, we present a 'media premiere'—a wall-sized presentation that is set to special music. The couple invites six to eight guests, and we serve hors d'oeuvres on silver trays by candlelight. As the lights

dim, the music swells, and the couple's wedding images come up on the screen. It's a once-in-a-lifetime experience. Our clients, their friends, and relatives fly in from all over the country and tell us that, besides their wedding day, this is one of the most unique moments of their life." This event can be scheduled as early as two weeks after the wedding. The "album architecture session" is completed the night of the media premiere—after the couple's guests have ordered and departed. Design is accomplished via a slide show. "We show how the images may be cropped right on the screen so they can visualize it," explains Judith. "We proceed through the whole wedding and write down the images they want. The order is placed when they leave that evening—and they remit payment for the order at that time. When the album is completed we mail it or they can pick it up at the studio gallery."

Brian shares this advice: "Find a mentor with whom to study. Be above-board and present yourself and your work to another photographer whose artistry you admire. Ask where you can do better. Enter your images in competition to become stronger professionally. Know your equipment and how to use every piece to the best of its ability. Don't always think you have to have the newest and greatest piece of equipment that's out there. It's not necessarily how much equipment you own; it's about what you know and what you do with it. It's understanding the technical and the creative, being able to meld the two together to make beautiful pieces of fine art.

"Studying with people whose work I appreciate has been very helpful to me through the years," explains Brian. "Develop relationships with other photographers both in and outside your area. A lot of learning takes place in the professional organizations: WPPI, PPA, ASP, and right down to the local-level meetings. I was trained more classically at Ohio State University, as well as by Monty Zucker, as a lot of us were. I incorporate a lot of the principals I've learned into my work. I've also learned from Dennis Reggie to appreciate the things that just happen. Dennis calls it photojournalism; we call it more of a documentary style—just running to see what happens and shooting it. Don't just stand there and watch—squeeze the trigger!"

Circular mats, either inset or on their own, add variety to the album. Here, the smaller circular photographs complement the larger images on the facing pages.

14. Patrick and Barbara Rice

RICE PHOTOGRAPHY, NORTH OLMSTEAD, OH
WWW.SONOPP.NET/RICEPHOTO

Patrick got an early start with his photography. "I received my first camera when I was six years old as a First Communion gift. I was the little photography brat who would run around taking pictures of everything. I took pictures as a hobby through high school, then got a 35mm camera and took it more seriously. When I attended friends' or relatives' weddings I began taking pictures and would give them to the couple for free. They would say, 'The pictures you took look better than the guy we paid.' I started shooting wedding photography for money in college as a supplement to my income. Upon graduating I took a job that I really didn't like and decided to build the wedding photography business. It took five years before I was able to give up that job and become a full-time wedding photographer."

Barbara started in junior high. "I was a Girl Scout earning a photography badge for brownie points. A couple years later I took a career resource test. One choice was animal husbandry and the other photography. I love animals but I have allergies and photography sounded inter-esting. My senior year in high school my teacher asked, 'Do you want to do a wedding?' I laughed and said 'Yeah, sure.' He started giving me details; I said 'You're serious.' That was my first wedding. After graduation I went to photography school for a year and ended up not going back because I started working for Olin Mills. I hated it at the time, but looking back, I realize that it gave me the basics that I needed to learn, which you don't get at school. I then worked for a privately-owned studio that did mostly weddings, and we did all our own color printing in-house."

Both Patrick and Barbara hold the Professional Photographers of America Certified Professional Photographer, Master of Photography, and Photographic Craftsman degrees. They also hold numerous degrees from Wedding and Portrait Photographers International and have won numerous awards for their prints in competition. In addition, the Rices have coauthored the book *Infrared Wedding Photography* with Travis Hill (published by Amherst Media), and speak regularly on photography across the country.

"We advertise in two national bridal publications and one local one," says Patrick. "We do a couple of bridal shows a year. A lot or our work comes from word of mouth. I feel word of mouth is the best source, but it's good to keep your name out there to remind people that you are still around. Seventy-five percent of our work is referral. It may be from past clients or from other industry vendors. We do 110 weddings a year, and probably fifteen of those are referrals from other photographers."

When someone calls, if their date is available, the Rices give them a

"I almost always have them walking out with thirty extra pages. And they are happy with it."

price range without going into specifics. Second, they're informed that the Rices shoot black & white along with color. Third, that the studio gives them all their proofs. "Beyond that I try to set up an appointment and have them come in," says Barbara. "I tell them we are different, and that I can't explain that difference over the phone."

In all packages the couple receives a set of proofs. The package purchased will determine how many images are created, how much time,

how many locations, how many enlargements, and if they receive an album. Their lowest package price gets the couple a set of proofs in a proof book with limited session time and no black & whites.

"We have a home studio in an area that is zoned commercial," says Patrick. "It's located on a main road and is easy to get to. We have a room where we take the clients, sit them down, and say 'Make yourself comfortable. We'll be with you in a couple of minutes.' We do this on pur-

The Rices use Art Leather as their album choice. This is a slip-in photo album. The blank book is filled with various mat openings, and photos are placed under the mat.

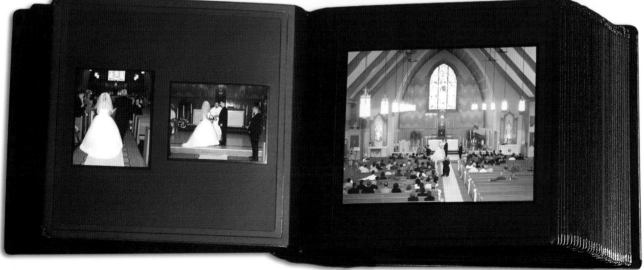

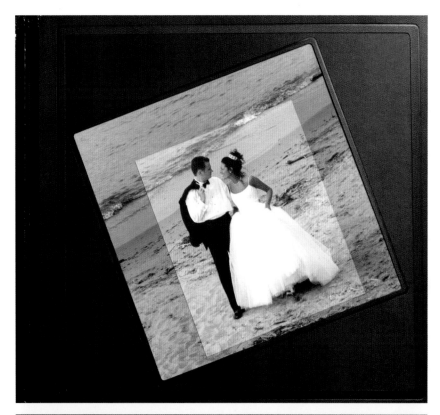

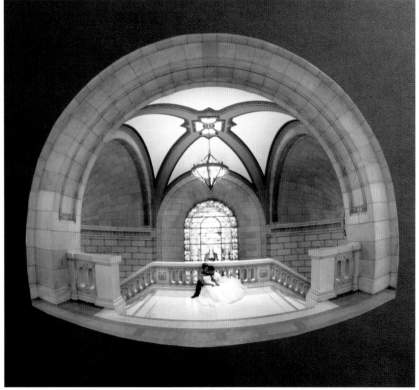

Top—This photo was printed full size about one-half to one stop darker than usual. Then, a smaller section of print, properly exposed, is mounted on the background photo. Bottom—This image was trimmed following the architectural lines and mounted on the page with no mat.

pose. There are no wedding albums out. There are bridal magazines on the coffee table and five or six photographs and awards on the walls. We want them to absorb that. We don't talk about ribbons and awards unless they ask. I want the people to have a chance to talk to each other without me in the room. I want them to absorb the things they see and notice the qualifications. I hand them a wedding album that is a combination of a lot of weddings. While they look at that I ask basic questions; I then reconfirm the date, get information on the church, reception, size of the wedding, and the number of people in the bridal party. I explain the type of images my clients are viewing, because we produce infrared photographs and soft focus and grainy images. We also do a lot of work with fisheye lenses." After they view a few albums of miscellaneous photographs the couple is shown a complete wedding story.

Barbara continues, "After we explain the images, and what we do and why, we go into the checklist, which gets down to the basics. I ask them to go over it. This gives us a starting point for the images we will capture. There's room on the back for special requests. By no means is that all the photographs that are going to be taken." The Rices use this as a sales tool to show that they are thorough in making sure all the images a couple may want will be taken.

"We ask the brides to look at the poses in their bridal magazines and

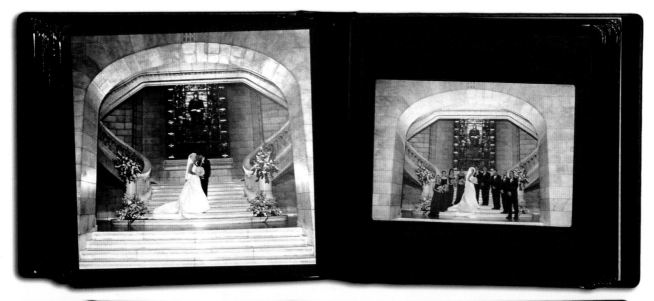

cut out images they like," says Barbara. "This lets the bride show us the type of images she prefers. We call them directed images. People can do what they see. When the wedding day comes we pull the image out and show it to them; they assume the pose; we take the picture; and in three seconds we are on our way."

The last ten minutes of the consultation is devoted to a discussion of the price list. "We explain our prices, then excuse ourselves from the room to give the couple time to talk about it. We come back in and see where they are."

General Products, Inc. is the major album company for the Rices. They also offer some Renaissance, Capri, and Art Leather selections. "I believe that we are open to most anything," says Patrick. "We offer different products because of the varying tastes of our clients."

After the proof book has been picked up the Rices try to get selections for the album back in three to four weeks. "I have them pick out

Using different sizes and shapes of images helps to create a variety of looks in your albums.

their images," says Barbara. "If they want my input I tell them to at least pick out the images they really like. This gives me a starting point. We do upsell. I tell them when they come back if they've got a package with, say, thirty 8x10s and fifty 5x7s 'When I sit down with you I'm not going to look at your sizes or how many prints you have, I'm going to go through your book and tell you what prints would be best in what sizes and lay this out for you.' I almost always have them walking out with thirty extra pages. And they are happy with it. Most albums end up around 100 pages."

For a different look and to add more pizzazz to the albums, the Rices create pages using ideas they have adapted from images they've seen in competition. For example, they take a page of sheet music and print it on parchment paper. That is placed in the 8x10-inch mat opening. A 4x4-inch image of the bride dancing with her dad or the groom is glued on top. "We try to use the song that they played," explains Patrick, "but it doesn't necessarily have to be that. We use Scotch 568 repositionable mounting adhesive, which comes in a roll from Albums Inc. We also do a lot of work with half-panorama pages." There is an extra charge for half- and full panoramas. They trim 4x5-inch prints to $3^{1}/_{2}$x$3^{1}/_{2}$-inch prints and paste them edge-to-edge, nine images on a page, for another interesting look. They receive many clients' requests for

A popular feature in the Rice's books is a sheet music page with a photo inset.

that. Another idea is to trim images down a little then make the same print, only darker, and mount the smaller photo on top of it. "People always stop when they come to that page and touch it.

"We are working with the Fuji Studio Master software. I was part of the focus group that helped design it. We were one of the first alpha sites that helped test it and then a beta site. It's similar to how Montage

works in that you grab your images and place them in the mat opening, crop, color correct, or retouch. You lay the images out on an album template. Each album company has their own CD of mat openings, you configure the album and send it to the lab. Labs are using a Fuji Frontier printer; you receive a 10x10-inch piece of paper with the images configured to match the mat opening that you chose. It slides into the mat and

matches. I have talked with Fuji about creating custom templates, because the lab doesn't care what you do. I will probably end up learning how to create custom templates so all the production I'm currently doing by hand can be done as mouse clicks on the computer. I look forward to that because I will be able to give the client thumbnails of what the final album will look like, or possibly even e-mail them their album design and have them sign off on it.

"We are looking at going completely digital with our weddings. Right now we are film with a little Canon D30 capture," says Patrick. "Ideally, we want to shoot the wedding, and before the couple comes back from their honeymoon, create an album design, present that and say, 'If you take it like this it will cost you this much. If you want to sit down and design it yourself, then you are back on regular prices.' We want to give them an incentive to buy

books that we can be proud of artistically. It can be disheartening to create great photographs, then have the client edit down to mediocre images."

The Rices' combine their images to create effective storytelling sequences. They also like to use black & white infrared images to add variety.

15. Bob Coates

BOB COATES PHOTOGRAPHY, SEDONA, AZ

WWW.BCWEDDINGPHOTO.COM

I came to photography late in life compared to most photographers in this book. Borrowing my roommate's 35mm camera to go on vacation when I was twenty-five years old, I managed to bring home some pretty good images. My girlfriend at the time (soon to become my wife) encouraged me by buying me a 35mm camera of my very own. Over the next thirteen years, I sporadically took photos, had a darkroom, had some one-man shows in small towns, and was a stringer for small newspapers and the Associated Press. In March of 1995 I decided to go pro and have never looked back.

Professional Photographers of America (PPA) was instrumental in helping me to understand photography as a business. Now I share my information on marketing by presenting a program on the local and national level. I have written articles for photography publications including *Professional Photographer, Rangefinder, Shutterbug,* and others. I'm certified and hold the Photographic Craftsman degree from PPA. There are a couple Fuji Masterpiece Awards on the mantle and some General and Loan Collection Prints on the wall.

Marketing for Bob Coates Photography is very hands-on. Business cards containing six images on the front with contact information and logos of photographic associations on the back are handed out everywhere I go. The business card case is as important as the wallet that holds my credit cards and cash when I leave the house. Press releases are sent out to the local papers approximately once every six weeks. There is also a strong Internet presence with lots of marketing to the search engines, which brings in a large number of inquiries.

I interview the couples as much as they interview me. If I sense even a little vibe that we are not on the same wavelength when it comes to what I produce and their expectations, I'll refer them to another photographer who I feel will be a better fit. Personality is important to the final album design. It's difficult to create wonderful photos if you don't get cooperation.

Pricing is set up with packages and an à la carte system. There are six packages. The most expensive one includes everything I ever wanted to sell at a wedding. No one has purchased it yet, but it sets the tone and makes the other packages seem more affordable. I use the à la carte price list for those whose needs aren't met by the packages. There is always a minimum that must be met. All money is due in full one week prior to the wedding unless the couple has elected to make time payments. In this case all monies are due before the final album is delivered. Dates are reserved with a retainer, which also locks in the prices quoted to the

"Then the fun begins: telling the story, adding backgrounds and text, placing multiple images, and adding special effects."

couple. All expectations and services to be rendered are put in contract form. This is for my protection as well as for the bride and groom.

My assistant, when not helping with lighting or running errands, is shooting. He's able to capture extra expressions when the subjects' attention is focused on me during formals as well as getting different angles. For example, when I'm catching the processional from inside the chapel he can be outside photographing the bride as she enters the ornate door. In the case of our many outdoor weddings in Sedona, I'll be photograph-

The couple is presented with a "proof magazine" containing 8¹/₂x11-inch sheets of photo paper with nine to twelve numbered images to a page. This is wire bound and put in an Art Leather aristahide cover.

ing up-close-and-personal while he can hike up the hill to get overview and scene-setting images. For many years I didn't work with an assistant, but now I wouldn't think of not having one.

My assistant and I shoot totally digital. The couple is presented with a "proof magazine" containing 8¹/₂x11-inch sheets of photo paper with nine numbered images to a page. This is wire bound and put in an Art Leather aristahide cover. Brides have told me they like this system better than proof prints because there is less bulk and no need to apply sticky notes to mark images for their album and reprint choices. Select images are also uploaded to my web site with a shopping cart attached. This is accomplished using Adobe Photoshop's web gallery feature. It's good to have a second com-

puter for doing automated production work so you won't be tied up.

Each bride prepares three lists from the proof magazine: favorite photos to be featured in the album; photos she likes but which don't necessarily have to appear, and images she definitely does not want. Then the fun begins: telling the story; adding backgrounds and text; placing multiple images; and adding special effects. The design of the book is very graphic, with multiple images on a page; drop shadows; text, and other features. When the layout is complete the album is uploaded to the web for approval.

Photos are printed in-house on an Epson 10,000 wide-format printer. Album prints are designed for the flush-mount style of album. I use the Leather Craftsmen 700-series for these. Prints are mounted back-to-

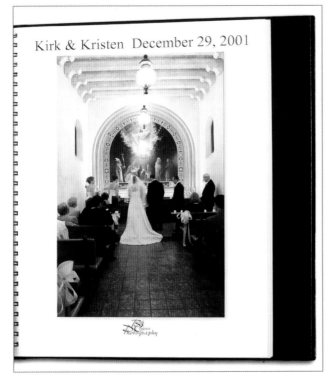

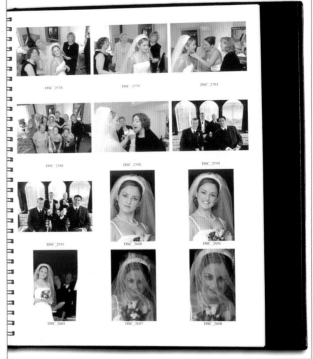

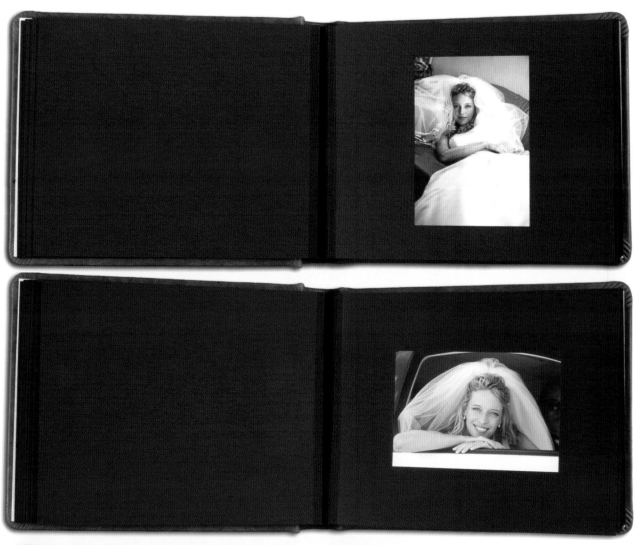

Above—Leather Craftsmen's Fine Art album with images presented on one side only. Left—Fine art album cover with outset photo and distressed leather.

back on an archival board and are sprayed and textured. These are bound into a top-grain cowhide leather cover and the edge of the print is visible. This edge can be gilded, but is not necessary. Most of my albums are designed with a photo inset in the cover and branded with the bride's and groom's names and date of the wedding. This is a great upgrade to the look of the albums.

Storyteller wedding books are another way of presenting images. Storyteller books are printed on an Indigo four-color press on 80lb textured cover stock and bound in a

Storyteller wedding books are printed by Creative Type in Dallas, Texas. Photos of these albums just can't do them justice—they have a very tactile feel with soft, manufactured leather and textured pages.

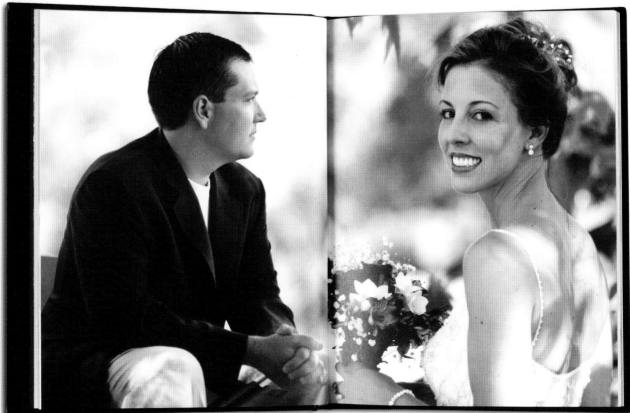

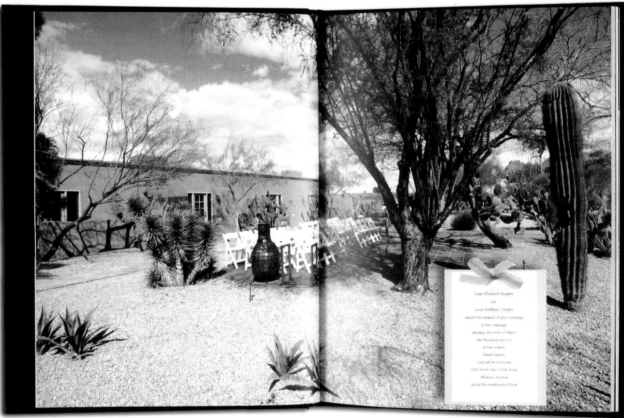

Files are sent after being converted to CMYK for printing. The Storyteller Wedding Book is a great way of getting a large number of images into an elegant and lightweight package.

glove-soft imitation leather by Creative Type printers in Dallas, Texas. Creative Type also offers the service of scanning your images and building the album according to your instructions if you don't want to do the actual layout in Photoshop.

My advice is to network with other photographers; share information, stories, and ideas, and attend as many photography seminars, classes, and conventions as you possibly can. Instruct other photographers one-to-one or present programs through PPA or other local and national organizations. It is amazing how much you learn when you teach and share your knowledge. I am the founder of two local photography groups— Virgin Islands Professional Photographers Association and Northern Arizona Professional Photographers. These are informal groups that meet monthly at members' homes or a local restaurant that has a meeting room. There are no dues.

Finally, study business and marketing as much as you study photography. Photography is a business. I have met a number of excellent image-makers who no longer work professionally because they didn't understand proper pricing, profit and loss, cost of goods sold, and how to get their business recognized through marketing.

This Art Leather Image Box contains individually mounted and matted images in a box with an inset image. They come in three sizes. Brass easels complete the display. Other companies produce similar products in different styles.

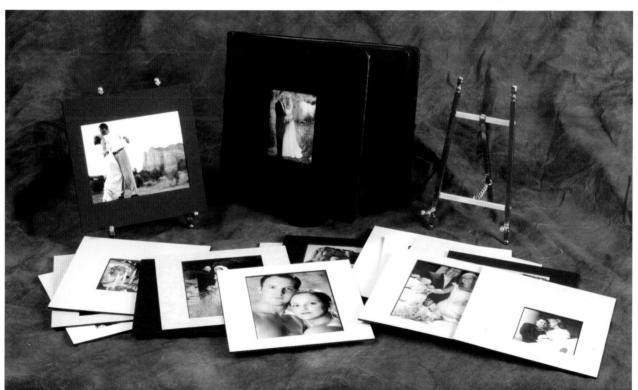

16. Album Design Overview

There are many different album types you can supply for your customers. Some albums are labor intensive on your part, others are not at all. You need to determine what type of market you are going after and find the product that will serve your needs as well as those of your market. The following paragraphs outline some of the factors involved with producing the various types of books.

For all albums you need to order a cover. If you are using a slip-in book with no personalization you can keep these in stock in your studio. Most album companies will create a custom die with your studio logo for imprint in the front inside-cover of the book. Some companies will charge you a one-time fee or will include the creation of the custom die for placing a minimum order.

If you wish to personalize each cover, you will need to order them individually. Customizing can include imprinting the names of the bride and groom and the date of the wedding or other text. This can be gilded in a variety of colors or even branded. Make sure you have the couple sign off on any text that will appear, especially the spelling of their names. This will save you from having to buy a new cover on occasion.

Your couples will have a choice of color, quality of leather, or other type of finish. With higher-end books, additional options—including hubs, tooling, or gilded edges—are available. Covers can also feature an inset photo (on lower-cost books you insert the photo into an opening left in the cover; with higher-end books, the photo is mounted during cover construction). In yet another style, an images is etched into an aluminum or acrylic cover.

Slip-in books are labor intensive and require assembly by the photographer. After deciding on the layout of the album, you choose the size of the book and order the type of cover, frames (pages), and inserts (mats) you need. Each side may have a different-shape insert, and these may be interchanged for variety. For example, the opening page may hold the invitation. The next page may have an 8x10-inch vertical print followed by two 5x7-inch prints, then an 8x10-inch horizontal photograph, followed by a page with four $3^{1}/_{2}$x5-inch images. The pages are inserted into the cover. These are the least expensive books to produce, but also the most labor-intensive. It also necessitates keeping pages and inserts in stock in your studio. Some companies that produce this type of

"There are many different album types you can supply for your customers. Some albums are labor intensive on your part, others are not at all."

album have a system in place where they will assemble the album and ship the finished product. There are companies that build slip-in books in bound fashion. You tell them what pages and mats you would like in the book and it is assembled at the album company. When it arrives in the studio you just insert the prints.

A bound book is a much stronger product. While it costs more, the client perceives a higher quality. In addition to the slip-in style, there are several other types of bound books available.

A reversible bound book allows images to be rotated in a horizontal or vertical position on the page. You can select a color for the frame and another color for the mat. Another color choice is made for the hinge. You lay out the pages the way you like and get an okay from your bride. Have your prints made and send them off with instructions to the bookbinder. Prints are numbered on the back with a soft graphics pencil (like a 4B). Some photographers will have their clients sign off on the final print quality before sending their prints to the binder. It's less expensive to get a print remade before it is glued into the book. Album companies will texture and spray the prints for protection as part of the production process.

A very popular bound book is called the flush mount. Images are mounted back to back on card stock flush to the edge of the book. There is no mat. These are extremely popular with digital photographers who prepare their own files and output to an inkjet printer or other device. This allows you to have multiple images on a page, or add text such as vows or poetry to the image. This is a less expensive way to get more images into a book. Some album companies will charge you by the print for each opening and mounting. This can really add up.

Magazine-style books are bound and are mounted much like flush mount books; they are usually printed on an RA-4 process machine, a laser-jet, or light-jet printer. These books are created from digital files. You can create the page design yourself if you are proficient in Photoshop. Many of these companies ask that you send the negatives or digital files to their design team, and they will create a finished book. For the do-it-yourselfer who is graphically challenged there are now companies creating templates for you to use. You will see more of these as more photographers move toward digital capture. Tread carefully here—a little graphic design can go a long way, and this look could become dated. Remember in the '70s when every album had a double exposure of the brandy snifter with the bride and groom inside?

Another digital product is a book printed on a CMYK press on regular (as opposed to photographic) paper. There are companies who will scan your negatives or work with your digital files to produce all the layouts and print the book. These are sometimes presented with a book jacket.

Image boxes are a different type of presentation. While not technically an album, an image box is a great alternative way for your bride to display her wedding images. All the choices available for a regular leather album cover are also available for the cover of the image box; leather-type, color, embossing, inset photo, etc. Photos are mounted and mated, then stored in the box. Lower-end boxes are available with slip-in mats. Image boxes can be sold with small easels and can also be marketed with a grouping of frames so the couple can change out images on a regular basis.

There are new products and ideas being created every day. Some photographers are creating multimedia presentations with images and music on CD or DVD as a companion piece for their albums. Keep your eyes open for new developments in album design.

"There are new products and ideas being created every day. Keep your eyes open for new developments in album design."

17. Album Design Terms

BY DAN HAMMEL (PPA CERT., CR.PHOTOG.)
OF LEATHER CRAFTSMEN INC.

TYPES OF ALBUMS

Book: Created from CMYK digital files, these books are printed on a digital press onto regular (nonphotographic) paper. These books are useful for getting many images into a smaller, lighter album.

Fine Art Library Bound: Designed to showcase a single image on a page with a fine, wide border. This mounting style has a museum or art gallery appearance. This is an ideal presentation to showcase a photographer's best work.

Flush Library Bound: Prints are mounted back to back and flush to the edges of a page. There is no mat, frame, or liner around any of the images. Photographic papers, dye sublimation, and inkjet prints work well for this application. Flush-mount books are available in a wide variety of sizes.

Magazine: Created from digital files, these albums contain multiple images and lots of artwork on the pages, which are usually mounted flush style.

Reversible Library Bound: Images are custom-mounted within a frame and liner. Prints can be vertical or horizontal and the person need not turn the book to view their images. This is a great presentation for varying sizes and multiple images on the same page.

Slip-In: These are manufactured albums that are assembled by the customer. Prints are slipped into the frames as opposed to the custom hand-mounting found in library bound books. This style of book is usually a less expensive presentation.

COVER DESIGN TREATMENTS

Cover Inset Photo: A flush opening within a cover into which an image may be mounted.

Cover Outset Photo: Raised frame within a cover where an image may be placed.

Custom Die: Metal die created for repeatable pressing into a cover surface, usually made with the photographer's logo.

Designer Leather: Polished leather, the same as that used in saddle making.

Distressed Leather: A richly textured hide that comes in a natural brown tone.

Euro Leather: Soft, non-grained durable leather that shows natural scaring in a hide.

Hubs: Raised bumps on a book spine.

Imprinting: Treatment used for names, monograms, dates, or a personal message on the album cover. This text can match the tooling color. Different print fonts are available for imprinting as well as custom dies.

Leather: Cover material available for library bound books. Note that top grain, euro, and lizard are spray dyed, while rustique, distressed, and designer leathers are vat-dyed.

Lizard Leather: Top-grain cowhide with a lizard-skin imprint pressed into the hide.

Other Materials: Covers may also be made of paper, cloth, glass, acrylic, metal, or wood.

Rustique Leather: Fine imported leather from Europe that shows natural scaring in the hide.

Spine: Side of the book that the pages are attached to. Custom books showcase a hand-rounded, hand-hammered spine.

Tooling: Lines that appear on a cover to frame the presentation. Lines can also be included on the book's spine. These lines can be gold, silver, black, and either branded or embossed. Also available with high-end books is 22K gold tooling.

Top-Grain Cowhide: Has graining that hides most imperfections in leather hides.

OTHER BOOK PARTS

Composite Page: Photos inset within another print. Usually a small image inset into an 8x10 or 10x10-inch photo. Can be square, circular, oval, or rectangular.

Endpaper: The lining on the inside of a book cover. Most linings have a moiré pattern and contrast with the cover color. Handmade endpaper is used in more expensive, custom presentations.

Frame: The actual page. These are available in a wide variety of colors.

Gilding: The color around the outside edge of a page. The gilding color is seen when the book is closed. Gilding is available in gold, silver, black, and no gild. 22K gold can be used in higher-end books.

Hinge: Linen tape that holds the pages in an album. These are available in colors that complement the frame colors.

Invitation Page: Blank frame placed at the front of an album to showcase the invitation to the special event. This makes a great title or opening page for any presentation.

Liner: Margins within a frame. These are also available in many colors. May match or contrast with the frame color.

Logo Page: Parchment pages that a studio imprint or logo can be stamped upon, as opposed to being stamped upon the inside cover.

Page Marker: Satin braided ribbons used to mark a viewer's place in a book. Page markers are used in higher-end albums and are seen most often in first editions, family bibles, and dictionaries.

Panorama: Full-bleed image spread across two facing pages.

Panorama, ½: Image mounted flush across one page.

Panorama, ¾: Image is mounted across one-and-a-half facing pages.

Slipcase: Protective case for books. Allows upright vertical storage. Most slipcases are covered in the same fine leathers as the album presentation.

18. Album Manufacturers and Suppliers

There are many different album manufacturers and suppliers to choose from. There are always new products on the market. Every effort was made to ensure that the information on this list is current and as complete as possible.

WEDDING ALBUM MANUFACTURERS

Albums Australia Pty. Ltd., Unit 17, 993 North Rd. Murrumbeena, Vic 3163, Australia, Tel: +61 3 9563 7099, Fax: +61 3 9563 7056, E-Mail Information: info@albumsaustralia.com.au, E-Mail Order: orders@albumsaustralia.com.au

Art Leather, 45-10 94th Street, Elmhurst, NY 11373-2824, Tel: 888-252-5286, Fax: 718-699-9339, Web Site: www.artleather.com

Capri Album Company, Inc., 510 South Fulton Avenue, Mount Vernon, NY 10550-2093, Tel: 800-666-6653, Tel: 914-776-6000, Fax: 800-791-3434, Fax: 914-776-6099, Web Site: www.caprialbum.com

Classic Album, LLC, 343 Lorimer Street, Brooklyn, NY 11206, Tel: 718-388-2818, Tel: 800-799-1931, Fax: 718-388-0214, Web Site: www.classicalbum.com

Daisy Arts, 225 5th Avenue, Suite 415, New York, NY 10010, Tel: 212-481-6245, Web Site: www.daisyarts.com, E-Mail: sales@daisyarts.com

Daisy Arts, 1312 Abbot Kinney Blvd., Venice, CA 90291, Tel: 310-396-8463, Fax: 310-399-2002, E-Mail: venice@daisyarts.com

DF Albums Ltd., 2315 de la Province, Longueuil (Québec), Canada J4G 1G4, US Toll Free: 888-570-5151, Canada Toll Free: 800-361-3621, Fax: 450-679-2935, Web Site: www.dfalbums.com, E-Mail: customerservice@dfalbums.com

Dia Creations Inc., 1305 Marie Victorin, Suite 700, Saint-Bruno (Québec), Canada J3V 6B7, Tel: 866-441-9777, Tel: 450-441-9777, Fax: 450-461-3105 E-Mail: creationsdia@qc.aira.com

DigiCraft, 31 Stormbird Drive, Noosa Heads Qld 4567 AV, Toll Free: 1-8772-804-551, Web Site: www.digicraftonline.com, E-Mail: info@digicraftonline.com

General Products, 4045 North Rockwell Street, Chicago, IL 60618-3797, Tel: 800-888-1934, Tel: 773-463-2424, Fax: 800-GEN-PROD, Fax: 773-463-3028, E-Mail: GenProd@aol.com, Web Site: www.gpalbums.com

GraphiStudio, 14239 Selwood Drive, Praire Du Sac, WI 53578, Tel: 866-472-7441, Fax: 413-403-8316, Web Site: www.graphistudio.com, E-Mail: covert@chorus.net

HPI Holson Professional, 275 Gossett Rd., Spartanburg, SC 29307, Tel: 800-634-7980, Fax: 800-634-7984

Kambara USA, Inc., 18355 SW Teton Avenue, P. O. Box 747, Tualatin, OR 97062, Tel: 503-692-9818, Fax: 503-692-7929, E-Mail: kambara@Kambara.com, Web Site: www.kambara.com

Leather Album Designs, P. O. Box 349885, Columbus, OH 43234, Tel: 614-442-1002, Tel: 877-442-1022, Fax: 614-459-3596, E-Mail: albumguy@aol.com

Leather Craftsmen Inc. East, 51 Carolyn Blvd., Farmingdale, NY 11735, Tel: 800-275-2463, Tel: 631-752-9000, Fax: 631-751-9220, Web Site: www.leathercraftsmen.com, E-Mail: customerservice@leathercraftsmen.com

Leather Craftsmen Inc. West, 2113 South Yale Street, Santa Ana, CA 92704, Tel: 800-366-2828, Tel: 714-429-9763, Fax: 714-429-9768

Queensbury Leather, Ltd., 3-5/13a Waikaukau Rd., Glen Eden, Aukland, New Zeland, Tel: +64-9-818-6545, www.queensbury.com

Renaissance™, ALBUMX CORP., 21 Grace Church Street, Port Chester, NY 10573, Tel: 914-939-6878, Fax: 914-939-5874, Web Site: www.bridalalbum.com, Web Site: www.renaissancealbums.com, E-Mail: albumx@aol.com

Sandis Leather Album Mfg. Co., 289 Bridgeland Ave., Unit #105, Toronto, Ontario, M6A 1Z6, Canada, Toll Free: 800-899-7670, Tel: 416-787-2171, Fax: 416-787-7875, Web Site: www.sandisalbum.com, E-Mail: info@sandisalbum.com

Spicer Hallfield, *available through* Philip Mauer Photomount, 25652 Nickel Place, Hayward, CA 94545, Tel: 800-321-3686, Tel: 510-780-0500, Fax: 510-780-0511, Web Site: www.philipmauer.com, E-Mail: mauerphoto@aol.com

Storyteller Wedding Books, 1201 Oak Lawn, Dallas, TX 75207, Tel: 214-741-1978, Tel: 877-577-1970, Fax: 214-752-5278, www.creativetypebooks.com

The Photo Album Shop, P. O. Box 244, Hornsby, NSW 1630, Australia, Tel: 61-2-9476-2610, Fax: 61-2-9476-5192 E-Mail: service@photoalbumshop.com.au

Topflight, D. Davis Kenny Company, 4810 Greatland, San Antonio, TX 78218, Tel: 210-662-9882, Fax: 210-662-9887, E-Mail: topflt@texas.net, Web Site: www.topflightalbums.com.

Waterhouse Books, 158 Rt. 154, Chester, CT 06412, Tel: 860-526-1296, Fax: 860-526-5032, E-Mail: waterhouse@ snet.net, Web Site: www.waterhousebooks.com

White Glove First Edition Books, 8092 Warner Avenue, Huntington Beach, CA 92647, Tel: 714-841-6900, Fax: 714-841-9567, E-Mail: wgbooks@aol.com, Web Site: www.wgbooks.com

Zookbinders, Inc., 151-K South Pfingsten Road, Deerfield, IL 60015, Tel: 800-810-5745, Tel: 847-272-5745, Fax: 847-272-5978

WEDDING ALBUM SUPPLIERS

ABC Photo Imaging, 9016 Prince William St., Manassas, VA 22110, Tel: 703-396-1906, Tel: 800-368-4044

Albums Direct, Tel: 800-575-6222

Albums, Inc., 7217 Patterson Drive, Garden Grove, CA 92641, Tel: 714-379-3533, Tel: 800-662-1000, Fax: 800-662-3105

Albums, Inc., 150 Mason Circle, Suite A Concord, CA 94520, Tel: 925-676-3350, Tel: 800-821-8674, Fax: 925-676-9135

Albums, Inc., 6549 Eastland Road, Brook Park, OH 44142, Tel: 440-243-2127, Tel: 800-662-1000, Fax: 800-662-3101

Albums, Inc., 18175 SW 100th Ct., Suite B, Tualatin, OR 97062, Tel: 503-692-9828, Tel: 800-662-1000, Tel: 800-252-6757, Fax: 503-691-2858

Albums, Inc., 52-A Winer Industrial Way, Lawrenceville, GA 3045, Tel: 770-447-6677, Tel: 800-662-1000, Fax: 800-662-3103

Baldwin Pro Lab, 33 W. Josephine, San Antonio, TX 78212, Tel: 210-733-6898

C&S Distributors, 4953 W. Napoleon Ave., Metairie, LA 70001, Tel: 504-888-8249, Tel: 800-448-1351

Florida Photomount, Inc., 7347 S.W. 45th Street, Miami, FL 33155, Tel: 305-266-7676

Merit Albums Inc., 19438 Business Center Dr., North Ridge, CA 91324, Tel: 818-886-5100, Tel: 800-423-5546

Michel Company, 1151 S. North Point Blvd., Waukegan, IL 60085, Tel: 847-887-9066, Tel: 800-621-6649

Modern Photo Supply, 142 Chartley, Park Center, Reistertown, MD 21163, Tel: 410-833-2112, Fax: 410-526-4656

Papipo Inc., Pro Color Imaging, Edificio Citibank, Repot. Bechara, San Juan, PR 00920, Tel: 787-793-7330, Fax: 787-793-7514

Philip Maurer Photomount, 25652 Nickel Place, Hayward, CA 94545, Tel: 510-780-0500, Tel: 800-321-3686

Richmond Camera Shop, Inc., 213 West Broad St., Richmond, VA 23220, Tel: 804-648-0515, Fax: 804-648-3724

Skolnick Photo Frames, 29245 Dequindre Ave., Madison Heights, MI 48071, Tel: 800-972-5286, Fax: 248-547-2449

South Florida Photo Co. Inc., Pro Photo, 213 South Tyler Ave., Lakeland, FL 33801, Tel: 800-327-6429

The Camera Exchange, 6635 San Pedro, San Antonio, TX 78216, Tel: 210-341-4700

The Levin Company, 1111 W. Walnut St., Compton, CA 90222, Tel: 310-636-1801, Tel: 800-345-4999

The Stock House, 7644 West 78th Street Bloomington, MN 55439, Tel: 800-333-8124, Tel: 952-944-7511

The Stock House, 3129 N. 93rd Street, Omaha, NE 68134, Tel: 800-777-0517, Tel: 402-571-0330

Wooden Nickel, P. O. Box 527, Benton, KY 42025, Tel: 502-527-1270, Tel: 800-325-5179

Index

Other Books from
Amherst Media

Outdoor and Location Portrait Photography
2nd Edition

Jeff Smith

Learn how to work with natural light, select locations, and make clients look their best. Step-by-step discussions and helpful illustrations teach you the techniques you need to shoot outdoor portraits like a pro! $29.95 list, 8½x11, 128p, 60+ full-color photos, index, order no. 1632.

Wedding Photography
CREATIVE TECHNIQUES FOR LIGHTING AND POSING, 2nd Edition

Rick Ferro

Creative techniques for lighting and posing wedding portraits that will set your work apart from the competition. Covers every phase of wedding photography. $29.95 list, 8½x11, 128p, full-color photos, index, order no. 1649.

Professional Secrets for Photographing Children
2nd Edition

Douglas Allen Box

Covers every aspect of photographing children on location and in the studio. Prepare children and parents for the shoot, select the right clothes capture a child's personality, and shoot storybook themes. $29.95 list, 8½x11, 128p, 80 full-color photos, index, order no. 1635.

Wedding Photojournalism

Andy Marcus

Learn the art of creating dramatic unposed wedding portraits. Working through the wedding from start to finish you'll learn where to be, what to look for and how to capture it on film. A hot technique for contemporary wedding albums! $29.95 list, 8½x11, 128p, b&w, over 50 photos, order no. 1656.

Studio Portrait Photography of Children and Babies, 2nd Edition

Marilyn Sholin

Work with the youngest portrait clients to create cherished images. Includes tips for working with kids at every developmental stage, from infant to preschooler. Features: lighting, posing and much more! $29.95 list, 8½x11, 128p, 90 full-color photos, order no. 1657.

Professional Secrets of Wedding Photography
2nd Edition

Douglas Allen Box

Over fifty top-quality portraits are individually analyzed to teach you the art of professional wedding portraiture. Lighting diagrams, posing information and technical specs are included for every image. $29.95 list, 8½x11, 128p, 60 full-color photos, order no. 1658.

Storytelling Wedding Photography

Barbara Box

Barbara and her husband shoot as a team at weddings. Here, she shows you how to create outstanding candids (which are her specialty), and combine them with formal portraits (her husband's specialty) to create a unique wedding album. $29.95 list, 8½x11, 128p, 60 b&w photos, order no. 1667.

Fine Art Children's Photography

Doris Carol Doyle and Ian Doyle

Learn to create fine art portraits of children in black & white. Included is information on: posing, lighting for studio portraits, shooting on location, clothing selection, working with kids and parents, and much more! $29.95 list, 8½x11, 128p, 60 photos, order no. 1668.

Innovative Techniques for Wedding Photography

David Neil Arndt

Spice up your wedding photography (and attract new clients) with dozens of creative techniques from top-notch professional wedding photographers! $29.95 list, 8½x11, 120p, 60 photos, order no. 1684.

Infrared Wedding Photography

Patrick Rice, Barbara Rice & Travis Hill

Step-by-step techniques for adding the dreamy look of black & white infrared to your wedding portraiture. Capture the fantasy of the wedding with unique ethereal portraits your clients will love! $29.95 list, 8½x11, 128p, 60 images, order no. 1681.

Photographing Children in Black & White

Helen T. Boursier

Learn the techniques professionals use to capture classic portraits of children (of all ages) in black & white. Discover posing, shooting, lighting and marketing techniques for black & white portraiture in the studio or on location. $29.95 list, 8½x11, 128p, 100 photos, order no. 1676.

Posing and Lighting Techniques for Studio Portrait Photography

J. J. Allen

Master the skills you need to create beautiful lighting for portraits of any subject. Posing techniques for flattering, classic images help turn every portrait into a work of art. $29.95 list, 8½x11, 120p, 125 full-color photos, order no. 1697.

Studio Portrait Photography in Black & White

David Derex

From concept to presentation, you'll learn how to select clothes, create beautiful lighting, prop and pose top-quality black & white portraits in the studio. $29.95 list, 8½x11, 128p, 70 photos, order no. 1689.

Corrective Lighting and Posing Techniques for Portrait Photographers

Jeff Smith

Learn to make every client look his or her best by using lighting and posing to conceal real or imagined flaws—from baldness, to acne, to figure problems. $29.95 list, 8½x11, 120p, full color, 150 photos, order no. 1711.

Professional Secrets of Natural Light Portrait Photography

Douglas Allen Box

Learn to utilize natural light to create inexpensive and hassle-free portraiture. Beautifully illustrated with detailed instructions on equipment, setting selection and posing. $29.95 list, 8½x11, 128p, 80 full-color photos, order no. 1706.

Portrait Photographer's Handbook

Bill Hurter

Bill Hurter has compiled a step-by-step guide to portraiture that easily leads the reader through all phases of portrait photography. This book will be an asset to experienced photographers and beginners alike. $29.95 list, 8½x11, 128p, full color, 60 photos, order no. 1708.

Professional Marketing & Selling Techniques for Wedding Photographers

Jeff Hawkins and Kathleen Hawkins

Learn the business of successful wedding photography. Includes consultations, direct mail, print advertising, internet marketing and much more. $29.95 list, 8½x11, 128p, 80 photos, order no. 1712.

Traditional Photographic Effects with Adobe® Photoshop®

Michelle Perkins and Paul Grant

Use Photoshop to enhance your photos with handcoloring, vignettes, soft focus and much more. Every technique contains step-by-step instructions for easy learning. $29.95 list, 8½x11, 128p, 150 photos, order no. 1721.

Master Posing Guide for Portrait Photographers

J. D. Wacker

Learn the techniques you need to pose single portrait subjects, couples and groups for studio or location portraits. Includes techniques for photographing weddings, teams, children, special events and much more. $29.95 list, 8½x11, 128p, 80 photos, order no. 1722.

The Art of Color Infrared Photography

Steven H. Begleiter

Color infrared photography will open the doors to an entirely new and exciting photographic world. This exhaustive book shows readers how to previsualize the scene and get the results they want. $29.95 list, 8½x11, 128p, 80 full-color photos, order no. 1728.

High Impact Portrait Photography

Lori Brystan

Learn how to create the high-end, fashion-inspired portraits your clients will love. Features posing, alternative processing and much more. $29.95 list, 8½x11, 128p, 60 full-color photos, order no. 1725.

The Art of Bridal Portrait Photography

Marty Seefer

Learn to give every client your best and create timeless images that are sure to become family heirlooms. Seefer takes readers through every step of the bridal shoot, ensuring flawless results. $29.95 list, 8½x11, 128p, 70 full-color photos, order no. 1730.

Beginner's Guide to Adobe® Photoshop®

Michelle Perkins

Learn the skills you need to make your images look their best, create original artwork or add unique effects. All topics are presented in short, easy-to-digest sections that will boost confidence and ensure outstanding images. $29.95 list, 8½x11, 128p, 150 full-color photos, order no. 1732.

Professional Techniques for Digital Wedding Photography

Jeff Hawkins and Kathleen Hawkins

From selecting the right equipment to building an efficient digital workflow, this book teaches how to best make digital tools and marketing techniques work for you. $29.95 list, 8½x11, 128p, 80 full-color photos, order no. 1735.

Lighting Techniques for High Key Portrait Photography

Norman Phillips

From studio to location shots, this book shows readers how to meet the challenges of high key portrait photography to produce images their clients will adore. $29.95 list, 8½x11, 128p, 100 full-color photos, order no. 1736.

Group Portrait Photographer's Handbook

Bill Hurter

With images by the industry's top portrait photographers, this indispensible book offers timeless tips for composing, lighting and posing dynamic group portraits. $29.95 list, 8½x11, 128p, 120 full-color photos, order no. 1740.

Lighting and Exposure Techniques for Outdoor and Location Portrait Photography

J. J. Allen

Teaches photographers to counterbalance the challenges of changing light and complex settings with techniques that help you achieve great images every time. $29.95 list, 8½x11, 128p, 150 full-color photos, order no. 1741.

The Best of Wedding Photography

Bill Hurter

Learn how the top wedding photographers in the industry transform special moments into lasting romantic treasures with the posing, lighting, album design and customer service pointers found in this book. $29.95 list, 8½x11, 128p, 150 full-color photos, order no. 1747.

Success in Portrait Photography

Jeff Smith

No photographer goes into business expecting to fail, but many realize too late that camera skills alone do not ensure success. This book will teach photographers how to run savvy marketing campaigns, attract clients and provide top-notch customer service. $29.95 list, 8½x11, 128p, 100 full-color photos, order no. 1748.

Professional Digital Portrait Photography

Jeff Smith

Digital portrait photography offers a number of advantages. Yet, because the learning curve is so steep, making the tradition to digital can be frustrating. Author Jeff Smith shows readers how to shoot, edit and retouch their images—while avoiding common pitfalls. $29.95 list, 8½x11, 128p, 100 full-color photos, order no. 1750.

The Best of Children's Portrait Photography

Bill Hurter

See how award-winning photographers capture the magic of childhood. *Rangefinder* editor Bill Hurter draws upon the experience and work of top professional photographers, uncovering the creative and technical skills they use to create their magical portraits. $29.95 list, 8½x11, 128p, 150 full-color photos, order no. 1752.